POWER
COMPOSITION
for PHOTOGRAPHY

Develop Your Artistic Eye

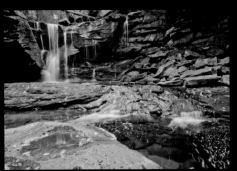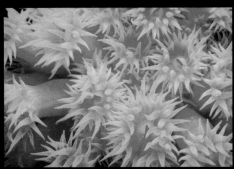

Tom Gallovich

AMHERST MEDIA, INC. ■ BUFFALO, NY

About the Author >>>

Tom has been photographing for over thirty years. His first camera, a Minolta X-570, was considered a good starter camera in the 1980s. At that time, he just wanted to document nature to create references for his paintings. As his skills and experience grew, he realized that his photos of nature were works of art in and of themselves. Now Tom photographs for the sake of photography.

Tom now has hundreds of thousands of images to his credit. He has taught classes and given many workshops at various community colleges. His work has been displayed numerous times at world, state, and local levels. During his commercial and portrait career he photographed over five hundred weddings and thousands of senior and family portraits.

For more information, please visit Tom's website at www.tom gallovich.com.

Published by:
Amherst Media, Inc.
P.O. Box 586
Buffalo, N.Y. 14226
Fax: 716-874-4508
www.AmherstMedia.com

Publisher: Craig Alesse
Senior Editor/Production Manager: Michelle Perkins
Editors: Barbara A. Lynch-Johnt, Harvey Goldstein, Beth Alesse
Associate Publisher: Kate Neaverth
Editorial Assistance from: Carey A. Miller, Sally Jarzab, John S. Loder
Business Manager: Adam Richards
Warehouse and Fulfillment Manager: Roger Singo

ISBN-13: 978-1-60895-847-4
Library of Congress Control Number: 2014944599
10 9 8 7 6 5 4 3 2 1

Check out Amherst Media's blogs at: http://portrait-photographer.blogspot.com/
http://weddingphotographer-amherstmedia.blogspot.com/

Contents

Dedication >>>

I'd like to dedicate this book to my mom and dad, Nick and Sylvia Gallovich. Through their endless encouragement and support, they gave me the confidence to complete this project.

This photograph was taken beside an old farm house near my home. We had spent days gathering bricks to finish my basement—another project with which they helped me! This photo was taken in the year of their 55th wedding anniversary. During the production of this book, they were celebrating their 63rd wedding anniversary.

Thank you, Mom and Dad.

Sincerely,
Tom Gallovich

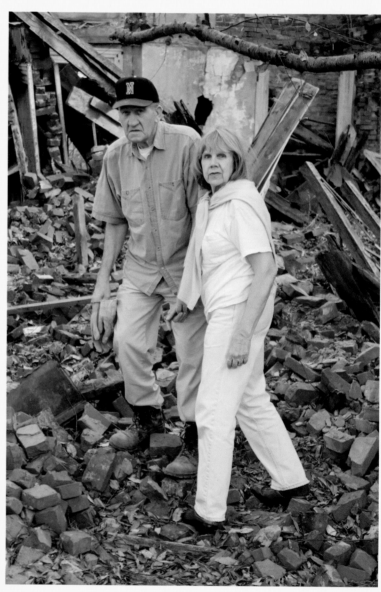

Nick and Sylvia Gallovich. Burrell Township, PA. Canon EOS 10D with 28–135mm f/3.5–f/4.5 lens at 47mm. Exposure: ISO 400 at $1/250$ second and f/4.5.

Introduction

What Is Composition?

Composition is the arrangement of lines, shapes, and colors that will define the subject of an image. It's a practice used both by painters and photographers. When painting, an artist will rearrange the image elements on the canvas to create the desired composition. Using tools such as thumbnail sketches and value studies, the artist will have a good idea how to prepare before he paints. There is time to change the color, lines, or the size of the shapes in the art work even once the painting is underway: artistic license allows for changes to be made as the painting evolves.

The artistic approach to photography is different. In this digital age, endless "enhancements" can be made using Photoshop or other image-editing programs. However, the compositional aspects of the image should be considered before the photo is taken. There are many tools that can be used to help you create a strong composition. Among them are your lens's focal length (or, if you're using a zoom lens, the focal length setting), the shutter speed you select, and your angle of view. "Good photos in, good photos out" should be your guiding principle. While it's true that great composition starts in the camera, it's also true that compositional rules apply to digital photo manipulations. In other words, you can do it now and/or do it later.

All of your photos will consist of a main subject or effect. This is usually why you origi-

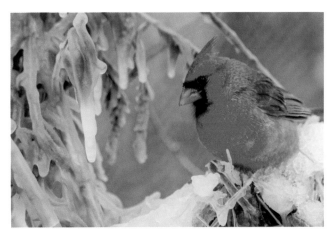

Cardinal in Vandergrift, PA. Canon EOS 7D with EF 100–400mm f/5.6L IS USM at 260mm. Exposure: ISO 100 at $1/180$ second and f/5.6. Tripod-mounted camera.

nally shot the image. Whether you are trying to portray a delicate butterfly or the raw power of a locomotive, there is a subject to be conveyed.

I tried to illustrate good composition using as many different types of subjects as possible. It is usually more of a challenge to portray green grass as your subject than it is to photograph a shiny new fire truck. The composition rules will tell why this is so. But remember: sometimes these rules are meant to be broken.

About This Book

Power Composition was designed to help you create stronger images, whatever your choice of camera or experience level. This is photography using an artistic eye. However, for the most artistic images possible, you will want to choose and use a camera that allows you to manually

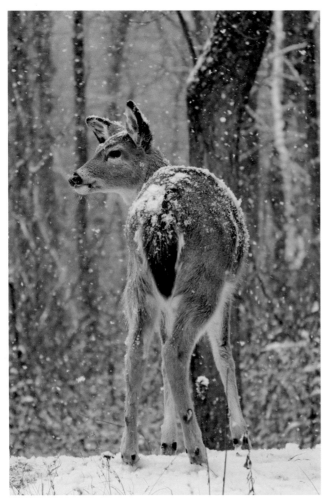

Snowfall in Vandergrift, PA. Canon EOS 30D with 28–135mm f/3.5–f/4.5 IS USM lens. Exposure: ISO 400 at $^1/_{180}$ second and f/5.6.

adjust your exposure settings (most compact/point-and-shoot cameras lack the options found on a digital single-lens-reflex camera, or DSLR). You'll want to take control of the way the camera renders your subject. Experimenting will help you expand your creativity and imagination. Any subject—cars, people, animals, or landscapes—can be portrayed in a wide variety of ways. You might choose to capitalize on the color intensity of the focal point of your image—or even render your subject as a sim-

ple silhouette. This is the artistic approach to photography.

This book was designed to be a quick reference guide. We'll start with an introduction to basic camera functions, and you will learn how depth of field, focal length, and shutter speed adjustments will affect your composition.

There are five main topics addressed in this book, and each is covered extensively in five chapters: Shape, Color, Line, Arrangement, and Artistic Considerations. Each chapter contains several elements or effects of composition. An element is a line or shape than can be manipulated to enhance your composition. An effect is the use of a camera function or an atmospheric event such as lighting or fog. To summarize, you will use your effects to enhance the elements of your composition.

In addition to the explanation of each element or effect, I have included a supporting graphic when needed. The miniature black & white photos are the graphic explanation of the written version. Any photograph shown with a red border is an example of how *not* to construct that particular compositional element or effect.

When first learning the principles of composition and design, there are many options to consider. After you've finished reading these pages and begin incorporating the ideas herein, you may want to come back to this book to reinforce what you've learned and brush up on concepts you may have forgotten.

The Power of Imagination

Imagine (facing page) is a digital composite of five different photographs. I arranged the elements of this piece to stir the imagination of the viewer. Positioning the word "imagine"

vertically allowed the shadow of the word to move up the steps, creating the depth I wanted. The image on the right wall is draining down into the ocean. To complete the surreal look, I included the reflections in the draining water. To create the realistic effect of the ocean, I digitally reproduced the waves over the pillars and the edge of the right wall. All the elements together create a clockwise movement.

I use this piece to illustrate one point: your imagination will be the most important tool you will use in creating your artistic images!

Note About the Images

The images that appear in this book were made using an Arca Swiss 4x5—with or without a 6x12cm film back—Hasselblad 6x6cm, and 35mm Minolta, Canon, or Nikonos V camera. Each format produces an image with a different aspect ratio. It is important to note that no image in this book was cropped in postproduction for improved composition.

Thank You >>>

I would like to thank Mary Ann Krupper for the dozens of hours she devoted to editing my original manuscript.

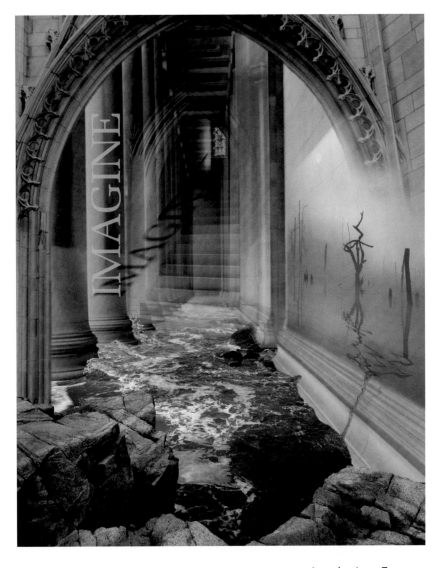

Imagine is a composite of five images. (1) The outside arch. Heinz Chapel main entrance, Oakland, PA. Hasselblad 501 CM with Distagon 50mm FLE f/4.0 lens. Exposure: Fuji NPH 400 at $^1/_{125}$ second and f/8. (2) The inside arch and steps. Heinz Chapel, Oakland, PA. Canon EOS 10D with 28–135mm f/3.5–4.5 lens at 28mm. Exposure: ISO 400 at $^1/_4$ second and f/11. Tripod mounted camera. (3) Sunrise photographed from a canoe in Glades Project, West Sunburry, PA. Minolta 9000 with Minolta 28–85mm f/3.5–4.5 lens. Exposure: Kodak KR 64 Kodachrome at $^1/_{60}$ second and f/5.6. (4) Pillars at the main entrance to CMU Oakland, PA. Hasselblad 501 CM with Distagon 50mm FLE f/4.0 lens. Exposure: Fuji NPH 400 at $^1/_{30}$ second and f/16. Tripod-mounted camera. (5) Foreground rocks and ocean. Monument Cove, Acadia National Park, ME. Arca Swiss F-1 with Schneider 90XL f/5.6 lens. Exposure: Provia RDP II 100 at $^1/_{125}$ second and f/5.6. Tripod-mounted camera.

Key Skills in This Chapter:

1. Selecting the best aperture/depth of field.

2. Choosing the lens focal length that provides the desired effect.

3. Blurring or freezing motion via shutter speed selection.

Sunrise. Beach Road, Assateague, VA. Canon EOS 7D with 28–135mm f/3.5–f/4.5 lens at 95mm. Exposure: ISO 400 at $^{1}/_{125}$ second and f/5.6.

Camera and Lens Controls

Aperture and Depth of Field

"Depth of field" is a term used to describe the distance between the nearest and farthest objects in an image that appear in focus. When only a small fraction of the scene appears in focus, the image is said to have a narrow depth of field. When the majority of the scene appears in sharp focus, the image is said to have a wide depth of field.

The depth of field that is evident in an image depends on the aperture setting used to take the photograph. When a wide aperture is selected (e.g., f/2.8), the band of focus is shallow. When a narrow aperture (e.g., f/32) is selected, the band of focus is much wider. In terms of composition, depth of field helps to guide the way the viewer experiences the image. For instance, if you chose a wide aperture of f/2.8 and focused on a white daisy roughly three feet away, the grasses and other flowers in the distance behind the flower would become progressively more blurred. This blur would render the background as a wash of color and less distinguishable shapes, and this would cause the eye to focus on the most sharp object in the image frame—the single white daisy.

Image 1.1 illustrates the difference in depth of field effects at three different aperture settings—f/5.6, f/11, and f/32.

The following is the range of common aperture or f/stop values.

f/2.8 f/3.5 f/4.0 f/4.5 f/5.6 f/6.7 f/8.0
f/9.5 f/11 f/13 f/16 f/22 f/27 and f/32

The depth of field that you see in your photograph is also affected by the focal length of your lens. If you were to select a focal length of 200mm and photograph a child using an aperture of f/8, you would have a much narrower band of focus (i.e., less depth of field) than you would if you photographed the same subject at f/8 with a wide-angle lens (20mm or 35mm). Landscape photographers use ultra-wide lenses, from 20mm to 35mm, as these focal lengths allow for greater depth of field and a razor-

Image 1.1. Apertures of f/5.6 (left), f/11 (center), and f/32 (right).

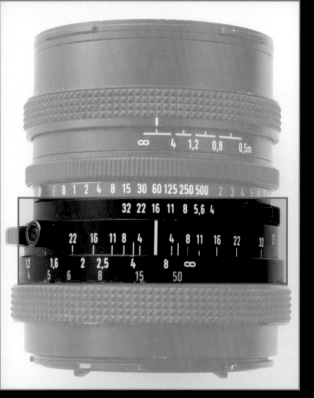

Image 1.2. A 50mm lens.

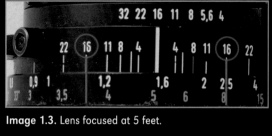

Image 1.3. Lens focused at 5 feet.

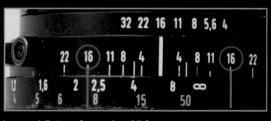

Image 1.4. Lens focused at 10 feet.

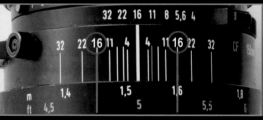

Image 1.5. Lens focused at 25 feet.

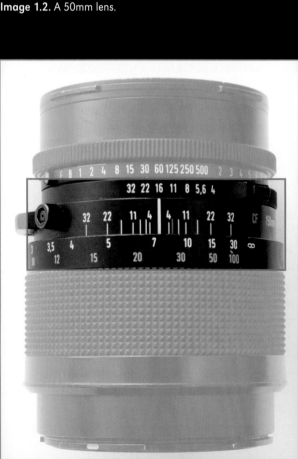

Image 1.6. A 150mm lens.

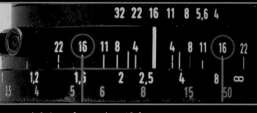

Image 1.7. Lens focused at 5 feet.

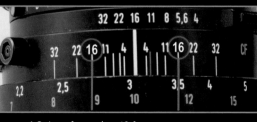

Image 1.8. Lens focused at 10 feet.

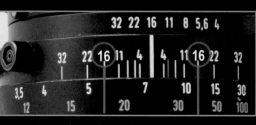

Image 1.9. Lens focused at 25 feet.

sharp image from the foreground to the background of your image.

A 50mm lens has always been considered a "normal" lens because it has a 46 degree angle of view, the same as the human eye. When lenses with shorter or longer focal lengths are selected, the angle of view changes. At shorter focal lengths, things appear farther away than they do to the naked eye. When longer focal lengths are used, things appear to be closer than they would be as viewed with the naked eye.

There is a formula we can use to help us understand what to expect from our lenses. Let's assume (as convention has it) that a 50mm lens is equivalent to a power of 1. Since the 50mm is equal to 1 power, all you have to do is divide any focal length by 50 to find the power of the lens. For example, if we were using a 300mm lens, we'd divide 300 by 50. Our lens would have a power of 6. In other words, a 300mm lens will make your subject appear 6 times closer than it really is. A person standing 60 feet away will appear to be only 10 feet away.

With an older-style manual lens, all the information you needed appeared on the lens barrel. The illustrations on page 10 (**images 1.2–1.9**) show the depth of field difference at f/16 with a 50mm and 150mm lens. The orange numbers represent the distance, measured in feet, from the object to the film plane (back of the camera). The white numbers indicate the same distance measured in meters. On this particular style of lens, the top row of white numbers shows the f/stop settings. To use this distance scale, follow the two 16s down to the orange numbers. The distance between the two red lines represents the area that will be in sharp focus. Note the difference between 5, 10, and 25-foot focus points.

I chose to use the f/16 setting because of an exposure guideline called the Sunny 16 Rule, which states that on a sunny day with 100 speed film (or at ISO 100 on your digital camera), your exposure will be $^1/_{125}$ second at f/16. This applies to any camera system or lens style.

Image 1.3 shows the 50mm lens focused at 5 feet. Following the red lines down shows a distance of about 3 feet, 9 inches to about 8 feet. This is the amount of depth of field you will have at a focus distance of 5 feet.

Image 1.4 illustrates the amount of distance you will have in sharp focus if this lens is focused on an object 10 feet away. From about 5 feet to almost 50 feet will remain in sharp focus. How would knowing where the band of focus lies in an image benefit me? Well, suppose I had a friend who wanted to be photographed with his new car. If I were 10 feet from the car, my friend and his entire car would be in sharp focus (on a sunny day). This would be a safe setting. If the sky were heavily overcast, I would have to "open up" the lens (choose a wider aperture). Suppose my new f/stop was f/8. Following the two opposing 8s down to the orange numbers, you would find that only from 7 feet to about 15 feet would appear in focus. In that case, the back end of the car would be out of focus.

Image 1.5 shows the ideal setting for a landscape photo. From 8 feet to infinity would be in sharp focus. In other words, if I had my family standing 15 feet away at the edge of the Grand Canyon, I would know that my family and the scene behind them, as far as I could see, would be in sharp focus.

Image 1.6 shows a 150mm lens focused on a point 5 feet away. Again, if you follow the red lines down to the orange numbers, you will see that a distance of only 4 feet, 9 inches to about

Depth of Field Preview >>>

Depth of field has a big impact on your image. So, how do you know what effect you can expect at any given aperture? If your camera offers a depth of field preview option, you'll want to use it.

When you focus your lens (manually or automatically) the aperture is, by default, wide open, as focusing systems work better when there is sufficient light. When you take the photo, the lens automatically closes down to the f/stop or aperture setting you've dialed in, and the exposure is made. After the image is taken, the lens opens up to its maximum aperture once more.

When you use the depth-of-field preview button, the aperture will be temporarily adjusted to your working aperture and you will be able to see the depth-of-field effects right away.

5 feet, 3 inches will be in focus. This means there is only about a total of 6 inches in sharp focus. This would apply to anything you would be photographing 5 feet away (**image 1.7**).

Focusing this 150mm lens to 10 feet (**image 1.8**) would give you a sharp focus from about 9 feet to about 11 feet, 6 inches away. If I placed two people approximately 9 feet, 6 inches away from me, I would know they would both be in focus—even if one stood in front of the other.

With the focus distance set at 25 feet (**image 1.9**), everything from 18 feet to about 40 feet would be in focus. This could be a good setting for photographing two tigers at the local zoo. By calculating the cats' distance from each other and from me, I would know whether they would both remain in sharp focus.

Some workshop attendees have asked me, "How do I know how far 30 feet is?" I remind them that they are holding an exceptional range finder in their hands. In other words, sharp focus on the tiger and the distance scale on the lens will tell you how far 30 feet is.

Let's use this final example setting of 18 feet to about 40 feet in sharp focus. If I placed my friend 20 feet away with his new car directly behind him, everything would remain in sharp focus. Keep in mind that I focused 25 feet away.

This would probably place my actual focus point on the windshield. Since the area in front of the subject is of no interest, I chose a focus point a little farther/deeper into the image.

There is a basic depth of field rule that states "One third in front and two thirds behind." Reviewing all of these examples will show that a third of the total depth of field was in front of the focus point and two thirds were behind the focus point. Using this system, I will sometimes focus just behind my subject.

Let's return again to the idea that depth of field can be used to enhance your composition. By controlling your depth of field, you decide what remains in focus and what does not. This is commonly referred to as "selective focus."

In the photo of the bride and groom (**image 1.10**), I had the groom stand just outside of my depth of field. This allowed me to create a visual emphasis on the bride. Using this approach rendered the groom as a soft-focus afterthought and put him into a "dream state," if you will. The f/8 aperture allowed me to create this effect. Had I selected an aperture of f/16 or smaller (e.g., f/22, f/32, etc.), the groom would not have been outside of the band of sharp focus. If I'd selected an aperture of f/4 or larger (e.g., f/2.8, f/1.4), the groom would be

so blurred that he would be unrecognizable. An aperture of f/8 left the groom just outside my depth of field at the most desirable distance from the bride.

In **image 1.11**, the butterfly remained within my very shallow depth of field because I kept the subject parallel to the film plane (the back of the camera). Using any given lens at its minimum focus distance may yield a depth of field less than 1 inch. As you can see, the emphasis is on the butterfly in this image. The defocused flowers fall away visually. This is a compositional choice made at the time of capture to produce a strong, impactful image.

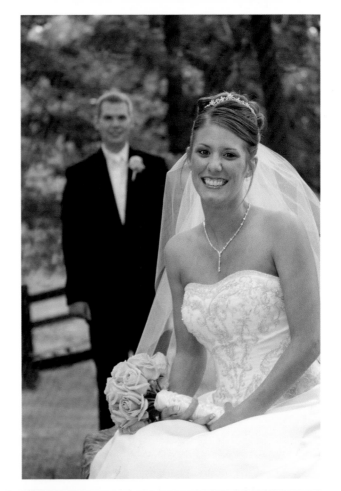

Image 1.10 (right). Dana Gais. Indiana, PA. Canon EOS 30D with 28–135mm f/3.5–f/4.5 lens at 100mm. Exposure: ISO 400 and $^1/_{125}$ second at f/8. **Image 1.11** (below). Tiger Swallowtail. Vandergrift, PA. Canon EOS 30D with 28–135mm f/3.5–f/4.5 lens at 100mm. Exposure: ISO 400 at $^1/_{250}$ second and f/11.

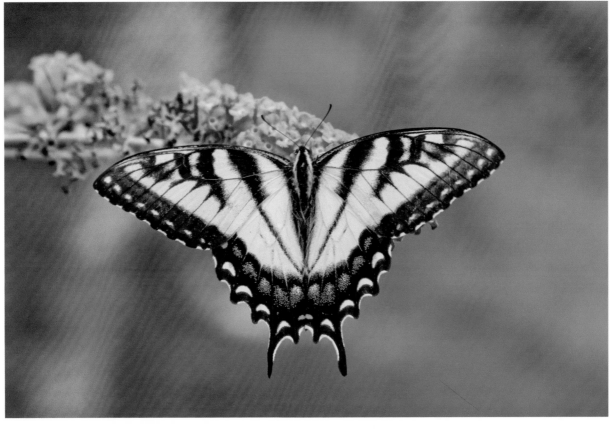

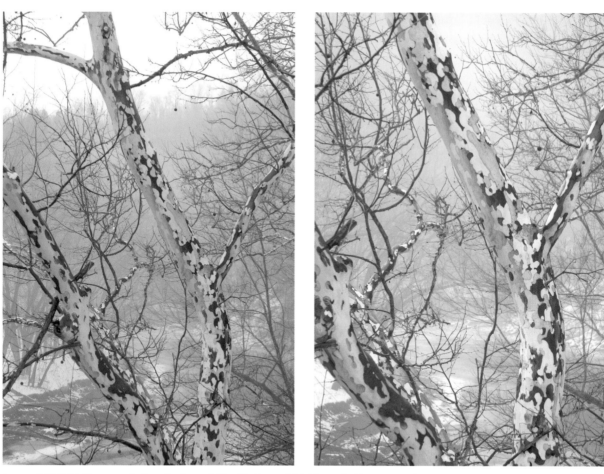

Image 1.12 (left). Sycamore before. Cochrans Mills, PA. Canon EOS 30D with 28–135mm f/3.5–f/4.5 lens at 41mm. Exposure: ISO 400 at ¹/₁₂₅ second and f/11. Image 1.13 (right). Sycamore after zooming in. Cochrans Mills, PA. Canon EOS 30D with 28–135mm f/3.5–f/4.5 lens at 65mm. Exposure: ISO 400 at ¹/₁₂₅ second and f/11.

Focal Length

Shooting at various focal lengths will create differing compositional options. You may carry several prime lenses and opt to shoot with a wide-angle lens (lenses with a fixed focal length like 20mm, 28mm, and 35mm) for a broader view of the scene or a telephoto lens (200mm, 300mm, and 400mm) to create more of a close-up look without changing your shooting location. Alternatively, you can simply carry a zoom lens, which will allow you to choose and use a variety of focal lengths (e.g., 28–135mm, 70–200mm, and 100–300mm). When you find something that seems to be a good photo opportunity but find that the resulting image is a little lacking, you might consider trying an alternate focal length for a different presentation.

Let's take a look at two photos of sycamore trees that show what a difference changing focal lengths can make. In the first photo (**image 1.12**), the bright shape the sky created was distracting. I zoomed in and took another photograph (**image 1.13**). By zooming in, I effectively cropped the bright, distracting area out of the image frame. As a result, the viewer is able to focus on the subtle detail of the tree

bark and the foggy monochromatic look this scene exhibited. (*Note:* These photos were taken from a bridge, and I shot from treetop level. Moving closer to the subject was not a possibility. I had to zoom in to achieve the composition I wanted.)

The sycamore tree images showed a subtle change from one photograph to the next, while the autumn scenes show a more dramatic result. **Image 1.14** was shot with a 28mm lens. This photograph has a bright, open look. In reviewing the shot, I felt the open sky competed with the falls in the foreground. By changing to a 50mm lens, I was able to crop in for a deep-woods feel. In this image, it is immediately clear that the falls are the subject. I prefer **image 1.15**.

If you like the first image better, that's okay. I have found that people usually base their opinions on their own experiences. In other words, some folks may like the open, bright look the first photo has. Changing your focal length while photographing your subjects will give you different results that may appeal to different people. Refining the composition of all of your photos will satisfy most of your viewers.

The falls images were taken minutes apart. I often go back to the same places year after year to look for a different perspective. For the sycamore tree example, I zoomed in using the same lens. I had to change to a different lens in the fall scene example. Both camera systems gave me the end result I was looking for.

Image 1.14 (left). Initial Roaring Run image, shot with a 28mm lens. Apollo, PA. Minolta 9000 with 28mm f/2 lens. Exposure: Provia RDP II 100 at ¼ second and f/16. Tripod-mounted camera. Image 1.15 (right). Roaring Run image shot with a 50mm lens. Apollo, PA. Minolta 9000 with 50mm f/1.7 lens. Exposure: Provia RDP II 100 at ¼ second and f/16. Tripod-mounted camera.

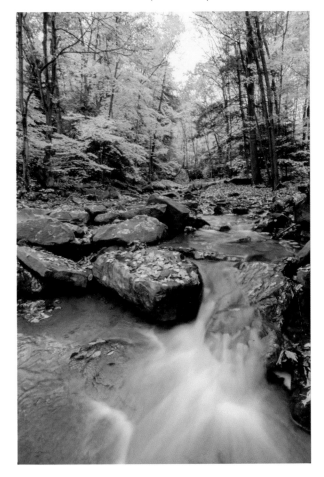 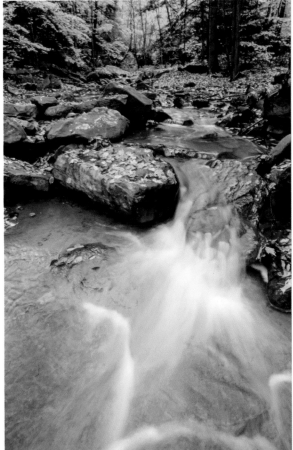

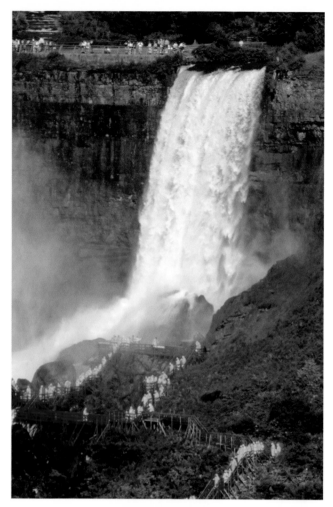

Image 1.16 (top). Bridal Veil falls. Niagara Falls, NY (photographed from Canada). Minolta 9xi with a 1.4x converter and a Minolta 300mm APO f/2.8 lens. Tripod-mounted camera. Image 1.17 (bottom). Raincoats. Niagara Falls, NY (photographed from Canada). Minolta 9xi with 1.4x converter and Minolta 300mm APO f/2.8 lens. Exposure: Provia RDP II 100 at ¹/₂₅₀ second and f/8. Tripod-mounted camera.

I have made several trips to Niagara Falls at different times of the year. **Image 1.16** and **image 1.17** were taken on a hot, bright, and sunny July day. This fact is not readily apparent in the closely cropped image. These images show how changing your focal length will open your eyes to new and different subjects and can yield more photographic and compositional options from a single scene.

No matter your subject, photographing with a wide-angle lens or a wide-angle focal length will show more of its environment. Look at the difference in the images obtained at the 28mm (**image 1.18**) and 135mm (**image 1.19**) focal-length settings. A 28mm setting offers an angle of view of about 65 degrees. The 135mm setting allows for a much smaller angle of view—only about 15 degrees. The photo made at a focal length of 28mm was shot from about one foot away, while the 135mm focal-length image was shot from roughly 8 feet away. Note how the space between the top and bottom of the shell is equal in both photos. However, the second photo reveals what would be excluded at the 135mm setting. *(Note:* I chose these lens settings because these are commonly used focal lengths.)

If you take a closer look at the image created using the 28mm setting, you will notice some distortion. The shell in **image 1.18** is much taller than the one in **image 1.19**, and the candles lean in opposite directions. The 28mm setting results in an exaggerated shell size as compared to the other objects in the photo.

How can we use the differences that result from selecting a wider or narrower view to our advantage? Well, the antler size on a buck in front of a hunter would be exaggerated if photographed with a 28mm lens. This would be

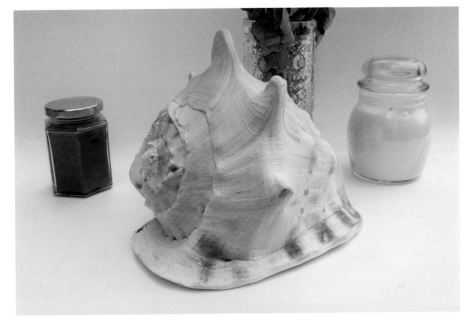

Image 1.18 (top). Still life 28. Vandergrift, PA. Canon EOS 30D 28–135mm f/3.5–f/4.5 lens at 28mm. Exposure: ISO 400 at $^1/_{250}$ second and f/13. Tripod-mounted camera.

Image 1.19 (bottom). Still life 135. Vandergrift, PA. Canon EOS 30D with 28–135mm f/3.5–f/4.5 lens at 135mm. Exposure: ISO 400 at $^1/_{250}$ second and f/13. Tripod-mounted camera.

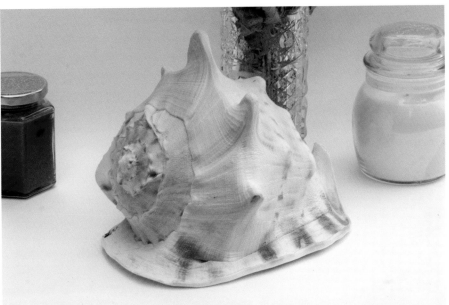

good for the hunter. In a portrait photographed with a 28mm lens, the nose size would be exaggerated. This would not be so good. This is why the 105mm setting is considered standard for portrait photography.

Remember, no matter the subject, moving in with a wide-angle lens or the equivalent focal length on a zoom lens is not the same as using more power. The difference would be far more drastic with a 20mm lens and a 300mm lens. The 20mm lens would have a 90 degree angle of view, as compared to the 6 degree angle of view of the 300mm lens. The dramatic difference between these two angles of view will completely change the appearance of anything that is behind your subject.

Image 1.20 (left). Sunrise 1. Vandergrift, PA. Canon EOS 30D with 28-135mm f/3.5-f/4.5 lens at 135mm. Exposure: ISO 100 at $1/60$ second and f/5.6. Image 1.21 (right). Sunrise 2. Vandergrift, PA. Canon EOS 30D with 28-135mm f/3.5-f/4.5 lens at 95mm. Exposure: ISO 100 at $1/90$ second and f/8.

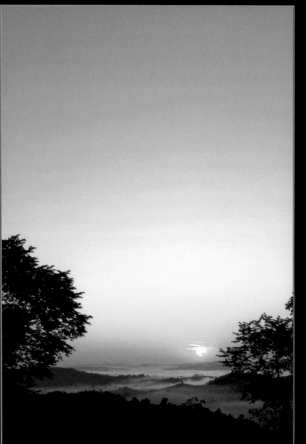

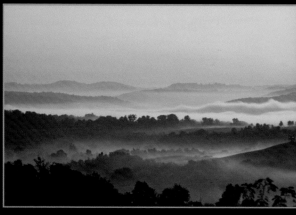

Image 1.22 (left). Sunrise 3. Vandergrift, PA. Canon EOS 30D 28-135mm f/3.5-f/4.5 lens at 28mm. Exposure: ISO 100 at $1/250$ second and f/5.6. Image 1.23 (right). Sunrise 4. Vandergrift, PA. Canon EOS 30D with 28-135mm f/3.5-f/4.5 lens at 135mm. Exposure: ISO 100 at $1/250$ second and f/5.6.

The four photos on the facing page were all taken within a twenty-minute time frame. They appear in the order in which I shot them. As I shoot a sunrise, I look to change the atmospheric effects and elements of composition for each photo.

1/60 second	1/125 second	1/250 second	1/500 second
1/4 second	1/8 second	1/15 second	1/30 second
8 seconds	4 seconds	1 second	1/2 second

1. **Image 1.20** was taken before the sun came up. At that time, the low-lying fog caught my eye first.
2. **Image 1.21** was photographed as the sun began to rise. I wanted to depict a sense of tension in the composition of this photograph.
3. **Image 1.22** shows the sun above the horizon line. The light source was too intense at this point to allow me to zoom in. Backing off to the widest angle of view gave me the opportunity to showcase the perfect blue sky. It is hard to find a sky without a trace of a cloud or a jet condensation trail somewhere.
4. **Image 1.23** was shot when the sun was too intense to be included in the photo. The sun was above the horizon line, so it produced a nice orange glow to the fog. The overall image is warm compared to **image 1.20**. Note that the image was shot without a filter and no digital retouching was done.

Shutter Speed

The shutter speed—the length of time that the shutter is open and allows light to strike the image sensor (or film)—is usually measured in fractions of a second. For action photography, the shutter speed you choose will have a direct impact on your composition and photo effects. This is because a fast shutter speed is needed to freeze motion and render a moving subject in sharp focus. To show motion blur for effect, a slow shutter speed is desired.

When photographing inanimate objects (e.g., landscapes), we typically want a very specific area (depth) of the scene to be rendered in sharp focus. Consequently, we select an aperture that will provide the effect we are after and choose a shutter speed and ISO that provide the required exposure given our desired aperture setting. When photographing action shots, on the other hand, our first and primary consideration is, "Do I want to use a fast shutter speed to freeze motion, or do I want motion blur in the frame for creative effect?" Either choice will affect the composition.

In the chart above, the green area shows the shutter speeds that can be used with a handheld camera. The yellow area shows the shutter speeds used for everyday shooting. This would include vacation photos and family photos. The shutter speeds in the yellow area can be used with a handheld camera *if* you have a steady hand. These speeds will give a slight amount of blur or softness to general action shots. Landscape photographers can render a waterfall in a soft blur for effect by choosing a slow shutter speed. Panning with a relatively slow shutter speed (tracking a moving subject with your lens) will result in a sharp subject and blurred background.

The shutter speeds that fall into the red area of the chart should be used only with a tripod-mounted camera. These shutter speeds are used

for lightning, ghost images, and for maximum-depth-of-field landscape photography. Let's take a look at all of these speeds and what they will do.

We will start with the red section of shutter speeds using our tripod.

For **image 1.23**, a self-portrait, I used my 4x5 camera. The shutter speed was 1 minute. After I started taking the photo, I walked into the scene. Standing as still as possible, I counted to 30 and then walked out. What this did was expose me for 30 seconds and what was behind me for 30 seconds. Thus, the ghost image was created.

It is impossible to shoot lightning in a reactive way. The more practical way is to predict where and when it will strike. In a good storm, I will locate the main storm cells and set my camera. I then count the seconds between each strike. I've determined there are, on average, 30 seconds between strikes. After a strike, I count to twenty and start taking my first photo. Since my shutter speed was determined to be 20 seconds, counting to twenty should take me into the next strike. This method could be used to take one photo at a time, but it is best to take a series of images in rapid succession to capture as many lightning photos as possible. (*Note:* The outer perimeter always produces the most crisp lightning photos. The heavy downpour of the inner cloud usually prevents a crisp shot.)

Image 1.24 was taken at dusk. Note the stars in the blue sky. The top of the cloud reveals the edge of the storm.

Image 1.23 (left). Self-portrait, 4x5. Linn Run State Park, PA. Arca Swiss F-1 with Schneider 210mm f/5.6 lens. Exposure: Provia RDP II 100 film at 1 minute and f/45. Tripod-mounted camera. Image 1.24 (right). Lightning. Vandergrift, PA. Canon EOS 30D with 28–135mm f/3.5–f/4.5 lens at 28mm. Exposure: ISO 100 at 20 seconds and f/11. Tripod-mounted camera.

 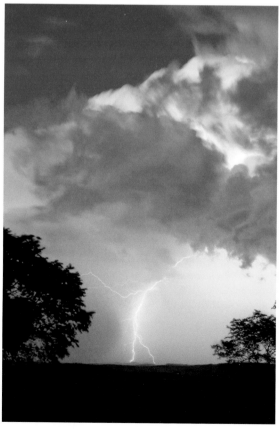

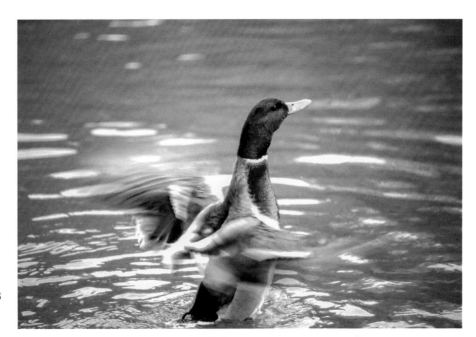

Image 1.25 (right). Mallard. Pymatunning Lake, PA. Minolta 9xi with Minolta 300 APO f/2.8 lens. Exposure: Provia RDP II 100 at ¹⁄₆₀ second and f/8.

Image 1.26 (left). Water with slow shutter speed. Cherry Run, Burrell Township, PA. Canon EOS 30D with 28–135mm f/3.5–f/4.5 lens at 135mm. Exposure: ISO 400 at ¹⁄₂₀ second and f/32. **Image 1.27** (right). Water with fast shutter speed. Cherry Run, Burrell Township, PA. Canon EOS 30D with 28–135mm f/3.5–f/4.5 lens at 135mm. Exposure: ISO 400 at ¹⁄₁₀₀₀ second and f/5.6.

In **image 1.25**, the mallard is drying its wings after preening. I used ¹⁄₆₀ second to photograph this action. The shutter speed was fast enough to keep the duck's body sharp but too slow to stop the wings. This effect shows action differently as compared to freezing the motion of the wings and body.

Images 1.26 and **1.27** show how changing your shutter speed will impact the look of your image when photographing a moving subject.

In **image 1.28** and **image 1.29** (page 22), the water did not change much from one photo to the next. This is due to the slow-moving

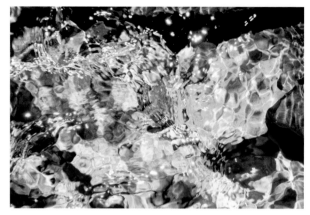

Image 1.28 (left). Maple leaf with slow shutter speed. Cherry Run, Burrell Township, PA. Canon EOS 30D with 28–135mm f/3.5–f/4.5 lens at 135mm. Exposure: ISO 400 at ¹/₁₅ second and f/27. Image 1.29 (right). Maple leaf with fast shutter speed. Cherry Run, Burrell Township, PA. Canon EOS 30D with 28–135mm f/3.5–f/4.5 lens at 135mm. Exposure: ISO 400 at ¹/₅₀₀ second and f/5.6.

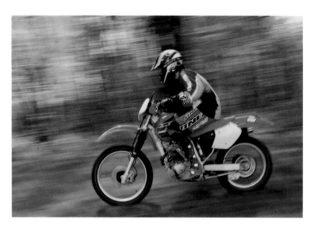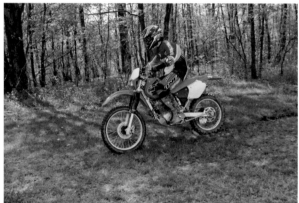

Image 1.30 (left). Dirt bike with slow shutter speed. Vandergrift, PA. Canon EOS 30D with 28–135mm f/3.5–f/4.5 lens at 100mm. Exposure: ISO 400 at ¹/₂₀ second and f/22. Image 1.31 (right). Dirt bike with fast shutter speed. Vandergrift, PA. Canon EOS 30D with 28–135mm f/3.5–f/4.5 lens at 28mm. Exposure: ISO 400 at ¹/₅₀₀ second and f/4.5.

ripple effect of the water. What did change was the the direct sunlight's reflections on the water. In the image taken at ¹/₁₅ second, the sun's reflection was moving throughout the duration of the exposure, thereby creating the white squiggly lines. In the image shot at ¹/₅₀₀ second, the reflections were rendered mostly as a spot. However, each and every "mound" of water was accurately depicted. In photography, there are many variables that can alter the end result.

Images 1.30 and 1.31 show a cyclist photographed using two different shutter speeds. The first photo reveals a blurred background due to the ¹/₂₀ second shutter speed. Panning with the rider at the same speed he is moving technically makes him a still object. This effect was enhanced by zooming in to the subject. Magnifying your focal power will also magnify the movement of the camera. The bike and rider are sharp; the background and wheels are blurred.

The second photo was shot at ¹/₅₀₀ second. The bike and background are razor sharp; there is no motion-blur effect.

In the shutter speed comparison images below, the atmosphere is changed, not the subject. For the first example (**image 1.32**), a slow shutter speed allowed the snow to remain in motion during the exposure. This resulted in a more visible doe standing next to the tree. The second example (**image 1.33**) was captured using a faster shutter speed. In this image, the motion of the falling snow was stopped. Either photograph could be effective depending on the mood you wish to establish or the message you intend to send. The first image shows a doe surviving the wind-driven snow. The second photo shows the doe as illusive and difficult to spot, even right in front of you.

Through our photographic travels, it is important to remember that practice and experimentation will enhance our creativity. If an atmospheric effect does not work on your current subject, it may work on the next one.

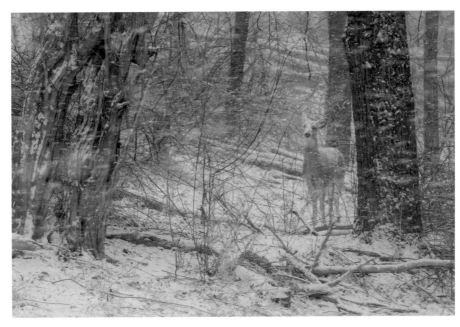

Image 1.32. Snow storm, slow shutter speed. Vandergrift, PA. Canon EOS 30D with 28–135mm f/3.5-f/4.5 lens at 100mm. Exposure: ISO 400 at $^1/_8$ second and f/22.

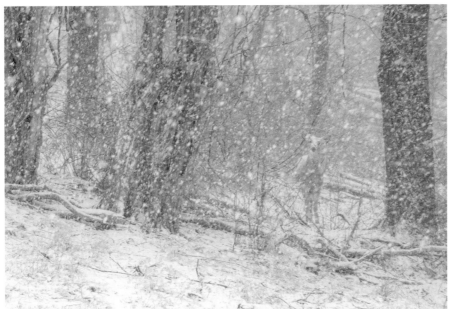

Image 1.33. Snow storm, fast shutter speed. Vandergrift, PA. Canon EOS 30D with 28–135mm f/3.5-f/4.5 lens at 28mm. Exposure: ISO 800 at $^1/_{125}$ second and f/8.

Key Skills in This Chapter:

1. **Working with or breaking like shapes.**

2. **Utlilizing overlapping planes to create a sense of depth.**

3. **Positive and negative space: what works?**

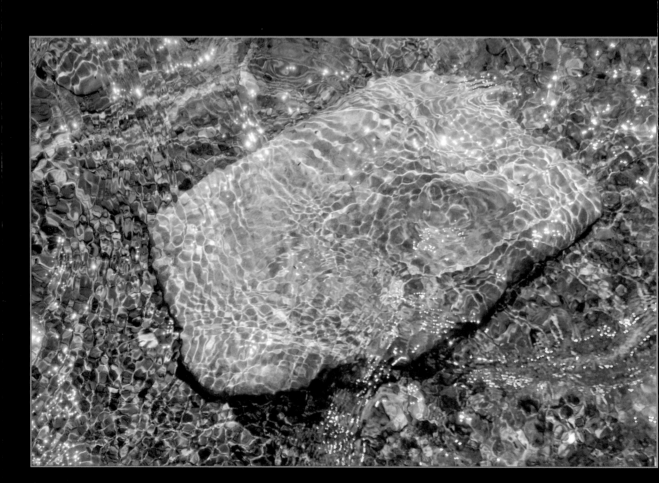

Rock at Lake Erie, Presque Isle State Park, PA. Canon EOS 30D with 28–135mm f/3.5–f/4.5 lens at 85mm. Exposure: ISO 100 at $^1/_{1000}$ second and f/5.6.

To get a feel for the impact of the shapes in your images and the way they contribute to the success of your photos, squint your eyes. When you do so, the details fall away and you are left with a general feel for the major forms in the image.

In the image on the facing page, the rock is the dominant component in black & white or color. What makes this photo more interesting is the natural filter the water creates. I used a fast shutter speed to freeze the moving water so that it broke up the edge of the rock by refracting the shape from under the water. The water's surface also reflected the direct sunlight from above.

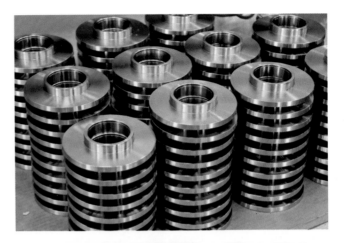

Like Shapes

The eye seeks out like shapes in an image. Therefore, incorporating similar shapes in your images will create a nice visual flow. The viewer's eyes will move from one form to the next, seeking to tie all of the like shapes together.

When repeated shapes are the main interest in the image, they read as a single mass and become the subject. In **image 2.1**, the ellipse and arc shapes appear over and over. No single ellipse jumps out at you; the light and dark areas keep your gaze moving across the image.

In **image 2.2**, the repetition of the individual triangular-shaped gingko leaves forms a sea of yellow.

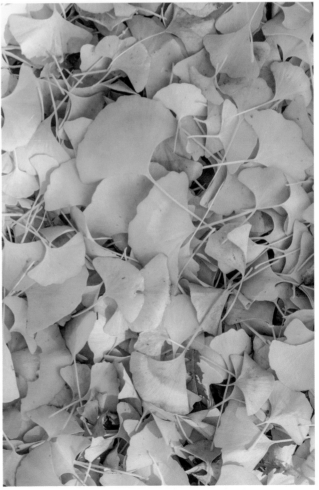

Image 2.1 (top). Machine parts. Vandergrift, PA. Canon EOS 30D with 28–135mm f/3.5–f/4.5 lens at 50mm. Exposure: ISO 800 at $^1/_{45}$ second and f/4.5. Tripod-mounted camera.
Image 2.2 (bottom). Gingko leaves. Oakland, PA. Canon EOS 30D with 28–135mm f/3.5–f/4.5 lens at 109mm. Exposure: ISO 400 at $^1/_{180}$ second and f/11.

With all art, the "artist" has the license to add, subtract, or create on the canvas.

As I composed the photograph of Michelle (**image 2.3**), I noticed the shapes and angles of

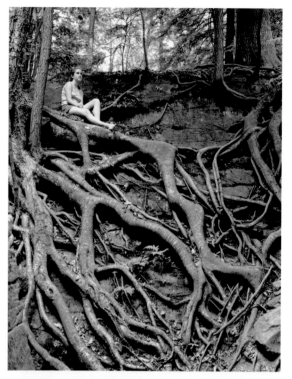

the roots. I asked her to bend her left leg and leave the right leg straight so as to mimic the root shapes. The roots form right angles and straight diagonal lines.

In black & white, shapes are more distinguished. With no color to distract the viewer, only highlights and shadows reveal the shapes.

In **image 2.4**, the long slender stems grow together to produce a triangular shape. The individual stems side by side are alike in color, so they do not dominate the photo. However, because the seaweed is a lighter value than the rock, the triangular shapes are revealed.

These shapes also reveal a counterclockwise motion. This creates a pinwheel effect that we will cover in chapter 4.

Image 2.3 (top). Michelle at McConnells Mill State Park, PA. Arca Swiss F-1 with Schneider APO-Symmar 210 f/5.6 lens. Exposure: Kodak T-Max 100 at $^1/_{60}$ second and f/5.6. Tripod-mounted camera. **Image 2.4** (below). Seaweed. Acadia National Park, ME. Minolta Maxxum 9000 with 28mm f/2.8 lens. Exposure: RDP II 100 at $^1/_{125}$ second and f/11.

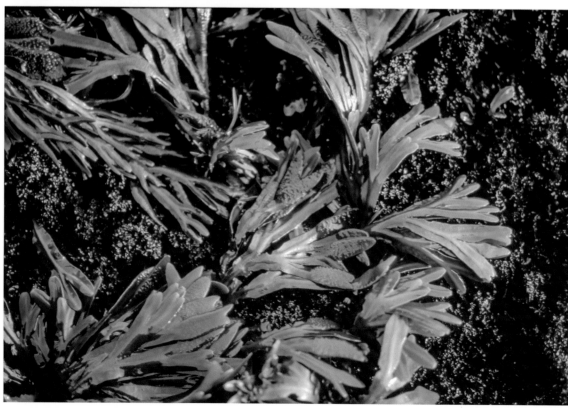

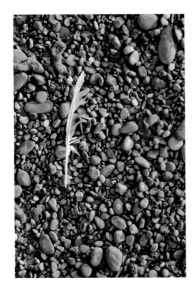

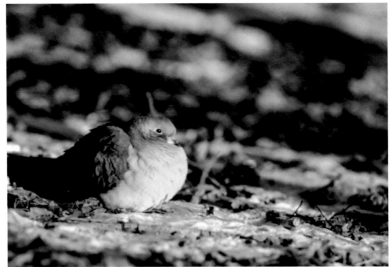

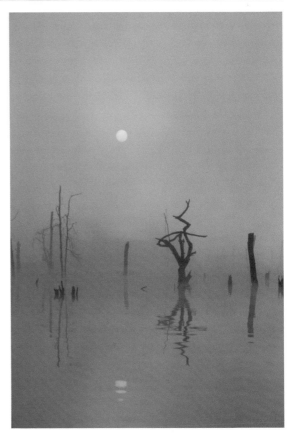

Image 2.5 (top left). Feather. Presque Isle State Park, PA. Canon EOS 10D with 28–135mm f/3.5–f/4.5 lens at 80mm. Exposure: ISO 400 at ¹/₁₂₅ second and f/4.5. Image 2.6 (top right). Mourning dove, photographed from a blind. Burrell Township, PA. Minolta 9xi with a 1.4x converter and Minolta 300mm APO f/2.8 lens. Exposure: Fuji RDP II 100 at ¹/₂₅₀ second and f/8. Tripod-mounted camera. Image 2.7 (right). Sunrise photographed from a canoe. Glades Project, West Sunbury, PA. Minolta 9000 with Minolta 28–85mm f/3.5–f/4.5 lens. Exposure: Kodak KR 64 Kodachrome at ¹/₆₀ second and f/5.6.

Breaking Like Shapes

We know that the human eye relates to similar shapes. Therefore, it can be said that a break in a pattern can also be a compelling subject.

In **image 2.5**, the feather is a long, linear form against the rounded pebbles. The whiteness of the feather enhances its impact. Even if the feather were darker (similar to the pebbles), it would be visible. The ability for a subject to stand out despite tonal similarity to the background will be made evident in further examples.

In **image 2.6**, the mourning dove is similar in tone to the background value. Squinting your eyes breaks this photo into different shapes. You end up with a circle (the dove) against several long diagonal lines.

Contrast may also play a part in distinguishing the subject from the background. Contrast and shape difference jointly reveal the subject. In this image, the shape difference defines the dove, not a patch of snow, as the subject.

In **image 2.7**, the silhouettes of the trees are all close to the same value. It is the squiggly tree

that most presents itself as a subject. This is a far different example than the feather and the dove photographs, which involve two shapes, one against the other. In this image, the squiggly tree is the unique shape as compared to all others.

In most scenarios, one compositional element will be the dominant factor to help isolate your subject. However, in general, the more elements you include, the stronger the final photograph will be.

In **image 2.8**, the leaf and cinnamon fern are similar in color. It is the shape of the leaf against the patterns of the ferns that portrays it as the subject. As in the dove photo, contrast and size also help to reinforce this.

Think of it this way: A one-inch circle would be noticeable against a pattern of one-inch squares, but not as noticeable as a three-inch circle against a pattern of one-inch squares.

Overlapping Planes

When planes overlap in a specific pattern, they create a directional flow. The spacing and size do not have to be equal, as in a row of dominoes or a marching band. Although they may be considered overlapping planes, we will also look at incorporating staggered shapes and sizes.

Overlapping planes create the impression of depth. Placing one object in front of another, in front of another, and so on displays the position of each object within the picture box. The picture box is the actual three-dimensional space the photo takes up. In **images 2.9** and **2.10**, the actual depth is about 30 feet.

Imagine if the rocks were scattered throughout the image and did not overlap. This would have produced a completely different result. You would not have the dominant flow from the bottom right to the upper-left corner that the overlapped boulders create.

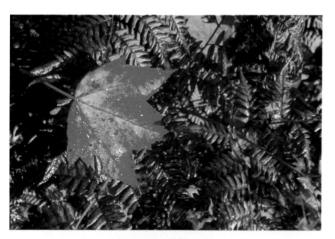

Image 2.8 (top left). Maple leaf. Canon Mountain, NH. Minolta 9xi with Minolta 28–85mm f/3.5–f/4.5 lens. Exposure: Kodak KR 64 Kodachrome at $^{1}/_{125}$ second and f/11. **Image 2.9** (bottom left) and **image 2.10** (bottom right). Boulders. Roaring Run, Apollo, PA. Canon EOS 30D with 28–135mm f/3.5–f/4.5 lens at 80mm. Exposure: ISO 100 at 2 seconds and f/16.

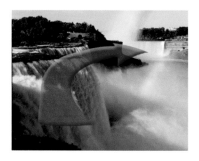

Image **2.11** (above) and **image 2.12** (right). Niagara Falls, NY. Arca Swiss F-1 with Schneider 90XL f/5.6 lens. Exposure: Fuji RDP II 100 at $^1/_{125}$ second and f/16. Tripod-mounted camera.

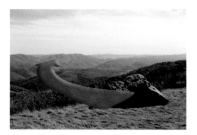

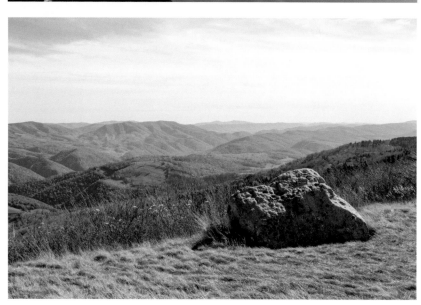

Image **2.13** (above) and **image 2.14** (right). Spruce Knob, WV. Canon EOS 30D with 28–135mm f/3.5–f/4.5 lens at 30mm. Exposure: ISO 100 at $^1/_{90}$ second and f/16.

Additionally, the first boulder in the lower-right corner has enough contrast to pull you back to the front of the photo from the end of your journey in the upper-left corner.

In **image 2.11** and **image 2.12,** the falls overlap from the lower left to the upper right. The tree line and wall in the upper right offer a strong contrasting end point to the flow. The dark lower-left corner against the water provides a returning point to start the journey over.

Images 2.13 and **2.14** show a typical example of overlapping planes. The picture box extends for many miles, adding atmospheric perspective to the mix. Because the mountains on the left side show more texture and detail, your eye is pulled in that general direction.

Positive and Negative Space

Negative space is the area that defines the borders of an identifiable object. The object is usually the subject of the image. A typical composition might show the subject in its environment. In this case, the subject would be the positive

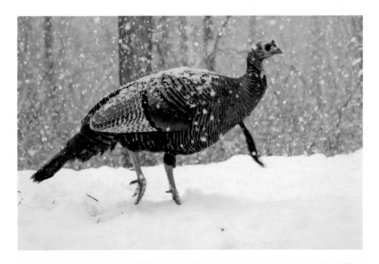

Image 2.15 (left) and **image 2.16** (above). Wild turkey photographed from a blind. Vandergrift, PA. Canon EOS 30D with 28–135mm f/3.5–f/4.5 lens at 117mm. Exposure: ISO 400 at $^1/_{250}$ second and f/5.6. Tripod-mounted camera.

Image 2.17 (left) and **image 2.18** (above). Sunlight. Oakland, PA. Canon EOS 30D with 28–135mm f/3.5–f/4.5 lens at 28mm. Exposure: ISO 400 at $^1/_{500}$ second and f/6.7.

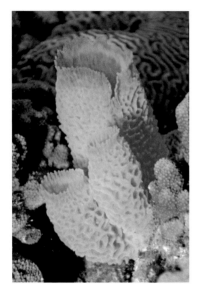

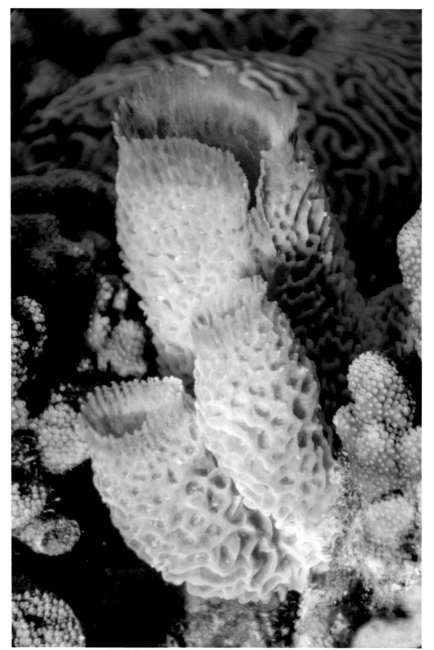

Image 2.19 and **image 2.20**. Purple vase sponge. Bonaire, NA. Nikonos V with Nikkor 15mm f/2.8 lens. Ikelite Substrobe 150. Exposure: Provia RDP II 100 at ¹/₆₀ second and f/8.

space and the environment would be the negative space.

In the photograph of the turkey (**image 2.15**), the positive space is clearly defined (the red area in **image 2.16**). This is due to the strong dark shape against the light background. If the subject of an image is not defined properly, then the positive and negative space will be difficult to distinguish. When the subject is defined properly, positive and negative spaces play an important role in keeping the composition interesting and balanced.

In **image 2.17** and **image 2.18**, the sky is the negative space. The leaves and branches make up the positive space in the image, and most of the composition is made up of positive space. It is the sun, however, that is meant to be the subject. In this example, the negative space holds the subject.

In **image 2.19** and **image 2.20**, some of the edges are well defined. In other areas, the edges blend into the background. This creates a compositional effect called "losts and founds"; the topic will be addressed in chapter 5. Even though the edges are not well-defined, they are part of

Image 2.21 (left) and **image 2.22** (above). Sunrise. Vandergrift, PA. Canon EOS 30D with 28–135mm f/3.5–f/4.5 lens at 85mm. Exposure: ISO 400 at ¹/₅₀₀ second and f/5.6.

the positive space. There are several different types of coral that create the edges of the purple vase sponge. The coral in the background would be considered negative space.

In **image 2.21** and **image 2.22**, the negative space is again the subject. The sunlight defines

the borders of the dark cloud, but it is the lighting effect within the negative space that is the subject.

Tall Shapes

Tall objects tend to push upward in a composition. If an object dominates all other shapes in the composition, then it creates a strong vertical movement in a upward direction. Obviously, a vertical format will help show how tall an object is in relation to the objects around it.

In **image 2.23** and **image 2.24**, the main fountain continues out of the photo. This will force the viewer to use their imagination to tell them how far it continues out of the frame. The empty space on the right of the spout provides the return path back into the image.

The fountain on the left occupies a large area of the image. This lends directional movement to the tall shape. Imagine a jagged tree line in the distance. If one tree were taller than the others, it would be eye-catching, but it wouldn't create directional movement. The entire treeline would be the dominant shape in the image.

Most compositional elements pique the curiosity of the viewer. Standing in Sequoia National Park, one has to look up just to see how tall the trees really are. Placing a tall, dominant shape in your composition will force the viewers to ask themselves, "How tall is that?"

Image 2.23 (above) and **image 2.24** (right). Fountain with water dyed pink in honor of breast-cancer awareness month. Pittsburgh, PA. Canon EOS 10D with 28–135mm f/3.5–f/4.5 lens at 28mm. Exposure: ISO 400 at $1/8000$ second and f/6.7.

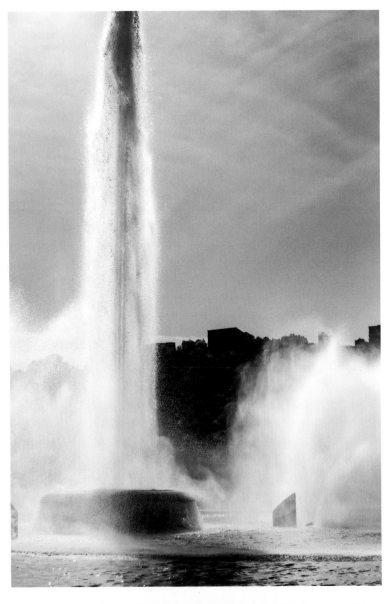

Key Skills in This Chapter:

1. Developing a strong monochromatic image.

2. Creating a dynamic image with complementary colors.

3. Harnessing the compositional power of intense color.

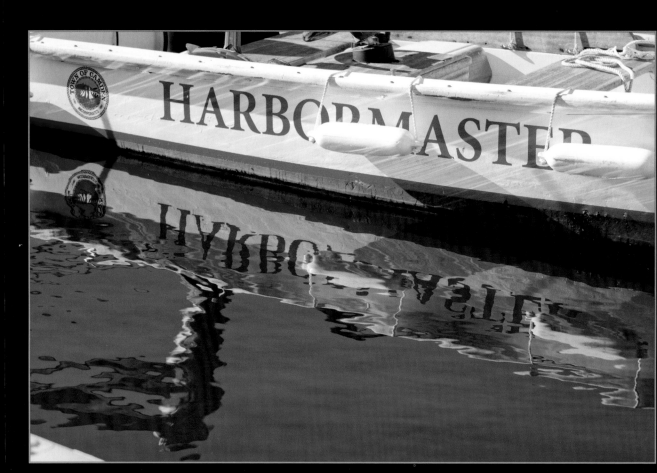

Image 3.1. Harbor master. Camden, ME. Canon EOS 7D with 28–135mm f/3.5–f/4.5 lens at 80mm. Exposure: ISO 100 at $^1/_{400}$ second and f/5.

Arguably, color will grab your attention before any other compositional element or effect. When most folks think of something colorful, they think of yellow, orange, and red—the warm side of the color wheel. A well-planned marine photo like **image 3.1** will generally be considered colorful. In this chapter, we will explore the ways that color will affect your composition.

Monochromatic Color

A monochromatic image contains the hues, shades, and tints of a single color. Hues are the intensity level of the color. Adding black to the color produces shades, while adding white produces tints. Monochromatic shots lack color contrast and often have a peaceful, dreamlike quality.

Attention! >>>

The color red demands attention. This is why many signs meant to attract your attention are red or contain red lettering. Stop signs and exit signs are obvious examples.

Image 3.2 was taken in the midst of a heavy snowfall. The bird, trees, and background show variations of blue. Because the bird is at rest riding out the storm, the monochromatic palette enhances the mood of the image. We're presented with a peaceful, relaxed bird in a believable setting.

When I am out taking photos, I often look for monochromatic scenes. These images are always a challenge to create successfully. Why?

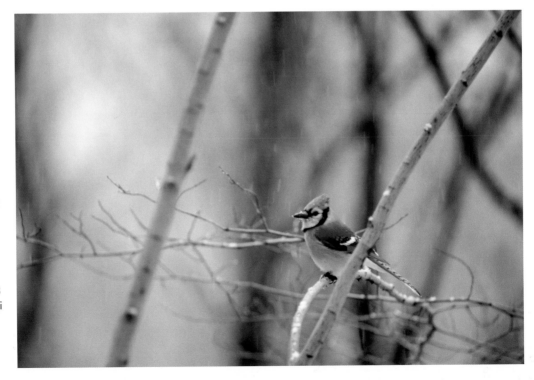

Image 3.2. Blue jay, photographed from a blind. Burrell Township, PA. Minolta 9xi with a 1.4x converter and 300mm APO f/2.8 lens. Exposure: Fuji RDP II 100 at $^1/_{125}$ second and f/4. Tripod-mounted camera.

Creating an effective one-color image that features a subject and other elements of composition is a big task. To be effective, the photograph must contain enough visual information to hold the viewer's attention.

I often use these types of photos for non-descript backgrounds in graphic design applications, such as a website.

Image 3.4 is a photo of a group of small corals. During the day, the coral tentacles are

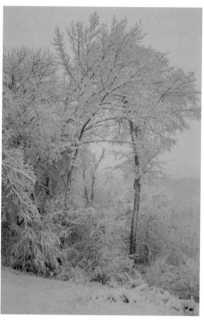

Image 3.3 (top left). Sand Beach, Acadia National Park, ME. Canon EOS 7D 28–135mm f/3.5–f/4.5 lens at 28mm. Exposure: ISO 100 at 1/400 second and f/14. **Image 3.4** (bottom). Orange cup coral. Bonaire, NA. Nikonos V with Nikkor 35mm f/3.5 lens and close-up kit. Ikelite Substrobe 150. Exposure: RDP II 100 at 1/60 second and f/11. **Image 3.5** (top right). Snow storm. Vandergrift, PA. Canon EOS 10D with 28–135mm f/3.5–f/4.5 lens at 28mm. Exposure: ISO 400 at 1/350 second and f/3.5.

Image 3.6 (top). Pemequid Point, ME. Canon EOS 7D with EF 14mm f/2.8L USM lens. Exposure: ISO 200 at $^1/_{250}$ second and f/8. **Image 3.7** (center). White birch. Acadia National Park, ME. Arca Swiss F-1 with Schneider 210mm f/5.6 lens. Exposure: Fuji RDP II 100 at 30 seconds and f/32. Tripod-mounted camera. **Image 3.8** (bottom). Casey. Vandergrift, PA. Canon EOS 30D with 28–135mm f/3.5–f/4.5 lens. Exposure: ISO 400 at $^1/_{180}$ second and f/8.

pulled in to produce nothing more than a brown lump. At night, they come alive to filter the water for food.

Each coral provides the shape and color to create an effective monochromatic photo.

In **image 3.5**, there is an overall gray cast. It's a monochromatic color image, but it almost appears to be a black & white photo. The fresh snow on the branches ties everything together. Without the fresh snow, the trees would be black silhouettes against a light background.

Color Unity

Color unity is achieved when the same color is used at multiple points throughout an image. As like shapes guide the eyes through the image, so do like colors. Incorporating color unity into your compositions will visually tie together select objects or shapes in the photograph.

Image 3.6 was shot during the fall season. The autumn colors are repeated throughout the frame, and the color change of the vegetation works well with the golds and browns of the rocks. Also, because the rocks are wet from a previous rain, their colors are enhanced.

Imagine the scene if it were early spring and the grass and low brush were a vivid green!

In **image 3.7**, the bark and snow share the same pastel blue and purple tones. If the tree were surrounded by deep greens or a leafy green tree was the center of focus in the image, the effect would be entirely different. The cool

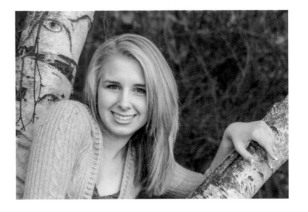

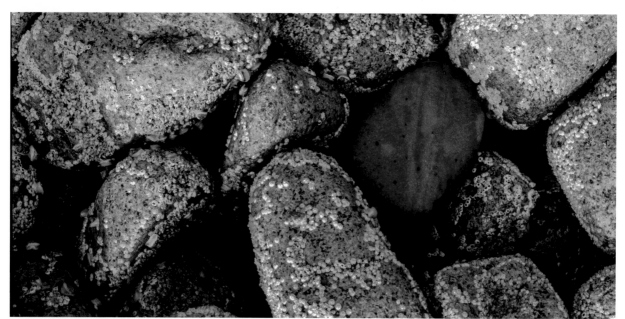

Image **3.9** (above). Pebbles. Acadia National Park, ME. Arca Swiss F-1 with Schneider 210mm f/5.6 lens. Horseman 6x12cm film back. Exposure: Provia RDP II 100 (220 film) at $^1/_{15}$ second and f/11. Tripod-mounted camera. **Image 3.10** (left). Mount Lafayette Peak, Franconia Notch State Park, NH. Hasselblad 501 CM with Distagon 50mm f/4 lens. Exposure: Provia RDP II 100 at $^1/_{125}$ second and f/16.

color cast of this winter photograph would have been lost.

In **image 3.8**, I asked my subject, Casey, to stand near the white birch to pull out the color of her sweater. The color unity between the sweater and tree renders those tones as a "lost" area. (We'll get to the concept of losts and founds in chapter 5.)

In the studio, color unity can be used to help create themes (e.g., pastels for spring scenes, earthy tones for autumn or Halloween sets). They may request that you wear clothing that works with a particular set they have in mind. In the studio as in the outdoors, strategic use of color unity will engage the viewer and draw the gaze through the frame.

Warm or Cool? >>>

Some watercolor artists take a unique approach to painting. They do not think of blues, reds, or any other specific color. They only consider whether a color is warm or cool. Consider composing a photographic image using the same mind-set.

Warm and Cool Colors

In **image 3.9**, the pebble shapes are very similar. One pebble is a cool blue color. All other pebbles are a warm brown with barnacle shell growth. The single blue stone stands out as the subject.

Warm and cool colors can be strategically used to establish mood in your image. If the tones are not wisely used, they can also detract from the message you intend to send to the viewer.

In **image 3.10**, the patches of white in the foreground are frost from the late-morning fog. The morning temperature was just 18 degrees on the day the image was captured. The warm colors in the foreground make the scene appear more inviting, providing an interesting contrast to the blue sky and mountain range in the background.

Image 3.11 was photographed during the magic hour. Magic hour occurs for roughly one hour after sunrise or one hour before sunset. During the magic hour, the sun is at a low angle in the sky, and the light is warm, soft, and flattering. Everything the light strikes takes on an orange glow, while elements of the scene that are shadowed will remain their natural color. The effect is beautiful and cannot be mimicked by placing a warming filter over the lens.

In this image, there is a contrast between the orange glow of the shoreline and the sky-blue color reflected in the water.

Complementary Colors

Complementary colors are two colors opposite each other on the color wheel. A combination of complementary colors would be any two colors opposite each other on the wheel. For example, the complementary color of blue-green is red-orange. The complementary of yellow is violet, and so on.

Image 3.11. Sunrise and Monument Cove. Acadia National Park, ME. Canon EOS 7D with EF 14mm f/2.8L USM lens. Exposure: ISO 100 at ¹/₂₀ second and f/11. Tripod-mounted camera.

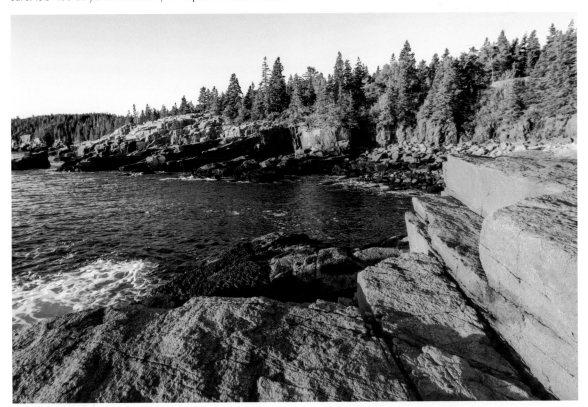

Image 3.12. Lotus. Upper Burrell, PA. Canon EOS 30D with 28–135mm f/3.5–f/4.5 lens. Exposure: ISO 400 at ¹/₁₈₀ second and f/11.

Image 3.13. Sea Snail. Cozumel, Mexico. Nikonos V with Nikkor 35mm f/3.5 lens and a macro kit. Ikelite Sub-strobe 150. Exposure: Provia RDP II 100 at ¹/₆₀ second and f/22.

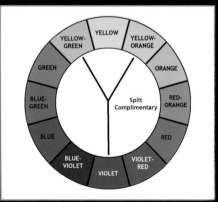

Image 3.14.
Complementary
color chart.

Image 3.15. Bass Harbor Light. Bass Harbor, ME. Minolta 9xi with Minolta 28–85mm f/3.5–4.5 lens. Provia RDP II 100 at 1/4 second and f/11. Tripod-mounted camera.

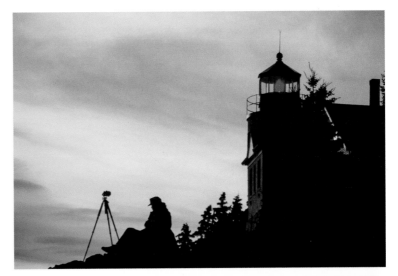

Image 3.16. Portland head light, ME. Arca Swiss F-1 with Schneider 90XL f/5.6. Horseman 6x12cm film back. Provia RDP II 100 (120 film) at 1/4 second and f/11. Tripod-mounted camera.

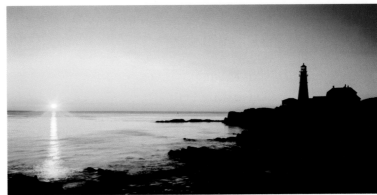

Complementary colors tend to vibrate next to each other. When complementary colors dominate an image, a powerful statement is made by color alone, no matter the subject matter. The strong color contrast the colors produce helps to create this effect.

In **images 3.12** and **3.13**, split complementary colors are used. A split complementary uses a color and the colors on either side of its complement. (See **image 3.14**.) In these two photos, it is violet and orange-yellow. Split complementary colors are contrasting, but with less intensity.

In **image 3.12**, there are two complementary color pairings: (1) the flower's purple petals and orange-yellow center and (2) the green tops of the leaves and their violet-red undersides.

Contrast

To make a dramatic color statement, just add black. Since black is the absence of all color, it will intensify any color next to it. Orange next to yellow is not too dramatic; however, orange next to black is intense.

In **image 3.15**, the red beacon is intensified by the black silhouette that surrounds it. A closer look reveals the photographer and his camera waiting on the sunset.

Image 3.16 shows a perfectly clear blue sky. The orange and blue are complementary colors that further intensify the image.

Intense Color

To grab someone's attention, fill your image with color that screams *color*. We know that complementary colors vibrate against each other. What if the entire image was filled with color? Remember this is a use of all colors, not just the warm yellow, orange, and red. Such intense colors may appear digitally enhanced, but they are natural.

I was lucky enough to dive the Caribbean a number of times and captured some of the most colorful photos I have ever taken. The electric blue of the water column is hard to forget.

In **image 3.17**, the blue color of the purple tube sponge occurs at a depth of roughly 45 feet.

In the upper right of the image, the waves on the surface are barely visible. At this depth, the water filters out all wavelengths of light except blue.

The hint of orange in the lower-left-hand corner is from my Ikelite SubStrobe flash. Any color other than blue would not exist without artificial light.

Image 3.18 is a close-up of a vintage Chevy hood ornament. The blue is painted and the fire-engine red is hard to miss. There are several other elements of composition involved. Can you detect them?

It should not be difficult to find colorful subjects. After all, they should be screaming at you.

Image 3.17 (bottom left). Purple tube sponge. Bonaire, Dutch Antiles. Nikonos V and Nikkor 15mm f/2.8 lens. Ikelite SubStrobe 150. Provia RDP II 100 at ¹/₆₀ second and f/11. **Image 3.18** (top right). Chevrolet. Butler, PA. Canon EOS 10D with 28–135mm f/3.5-f/4.5 lens at 85mm. Exposure: ISO 400 at ¹/₅₀₀ second and f/16. **Image 3.19** (bottom right). Barnacle shells. Bernard, ME. Arca Swiss F-1 and Schneider 210mm f/5.6 lens. Exposure: Provia RDP II 100 at 15 seconds and f/32. Tripod-mounted camera.

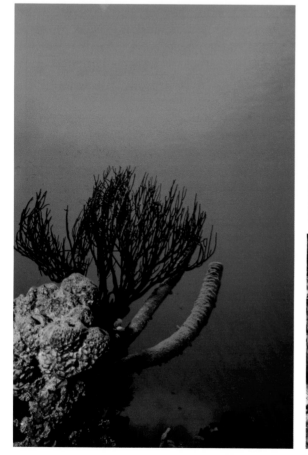

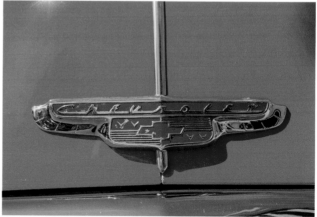

Image **3.20** (above). Fall leaf, before. Vandergrift, PA. Canon EOS 30D with 28–135mm f/3.5–f/4.5 lens at 135mm. Exposure: ISO 100 at ¹/₂ second and f/16. Tripod-mounted camera. Image **3.21** (right). Fall leaf, after. Vandergrift, PA. Canon EOS 30D with 28–135mm f/3.5–f/4.5 lens at 135mm. Exposure: ISO 100 at ¹/₂ second and f/16. Tripod-mounted camera.

The trick is to try to control the uncontrollable. Balancing intense color will take some planning. If you create a focal point that the viewer cannot leave, then the composition will lack a flow.

In **image 3.19**, the color is intense because the shells are wet. Look closely at the bottom middle and you will find a couple of dry spots. Without the water the shells are a light, washed-out gray—not very intense at all.

The images on the facing page prove that red screams color but usually requires a counterbalance. We will take a closer look at counterbalance in the next section of this chapter.

To capture deep color, you'll need to follow a few general guidelines. To introduce a nice warm glow to your photos, magic hour is the best. However, we are now after intense color across the entire image. This will require more than just an orangey light source.

Avoid direct midday sunlight; it wreaks havoc with reflective objects. Photographing in direct shade or on an overcast day will yield the best results. For outdoor photography, consider

subjects just after a rain. When objects are wet, their color deepens. Always bracket your shots if your camera will allow it. You may find that your underexposed photo works best.

A reflective surface is a color killer. **Image 3.20** was taken in ideal conditions—on an overcast day just after a rain. The camera was tripod-mounted, and the lens was only about a foot above the leaf. The sky was still too bright and produced a strong white-ish reflection over most of the leaf. To eliminate the reflection, I held my hand alongside the lens to block the direct skylight. This produced a simple yet effective result in **image 3.21**.

Note the color intensity difference between the dry and wet areas of the leaf.

Red and White

As proven in the "before" photo of the fall leaf (above left), the colors red and white demand attention. Using red or white as your subject color should require some balance. I say *should* because the rules are meant to be broken.

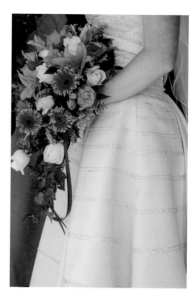

Image 3.22 (top left). Montego Bay, Jamaica. Hasselblad 501 CM with Distagon 50mm f/4.0 lens. Exposure: Provia RDP II 100 at ¹/₁₂₅ second and f/16. **Image 3.23** (top right). Hollabaugh wedding. Apollo, PA. Canon EOS 10D with 28–135mm f/3.5–f/4.5 lens. Exposure: ISO 400 at ¹/₃₅₀ second and f/5.6. **Image 3.24** (bottom left). Early snow. Vandergrift, PA. Canon EOS 30D with 28–135mm f/3.5–f/4.5 lens at 41mm. Exposure: ISO 400 at ¹/₃₅₀ second and f/4.

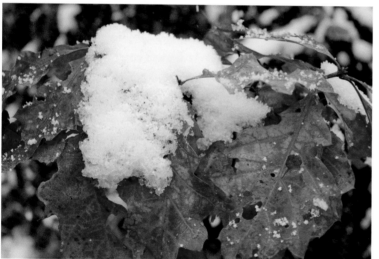

I shot the white urns in **image 3.22** at an angle to diminish the size of the one on the left. If they were both the same size, they would compete for the title of subject.

The urn on the left is just large enough to pull your attention away from the larger white shape on the right. My intention was to draw the viewer's eyes from one side of the photo to the other while he or she glanced at Montego Bay in the background.

Image 3.23 shows color against a white wedding dress. In this photo, the white shape counterbalances the color of the flowers.

Image 3.24 illustrates the opposite effect. In this image, I used the red leaves to counterbalance the white snow. Because of the contrast, the white snow grabs your attention first. The red edges of the leaves move the eyes through the rest of the image. Because the red leaves are

tonally similar to the colors in the background, they are somewhat subdued; the white snow demands more attention.

Image 3.25 is not digitally enhanced. The magenta, red, and deep-orange colors of the blueberry bush in fall is spectacular. The color of the lichen-covered granite is also true to life. If you look closely, you can see the natural rose tones in the granite.

In this photo, I used the strong texture of the rock to

balance the red. We will talk about texture and detail in chapter 6.

In **image 3.26**, the red is loud and clear. Does the dark shadow of the birch branch draw

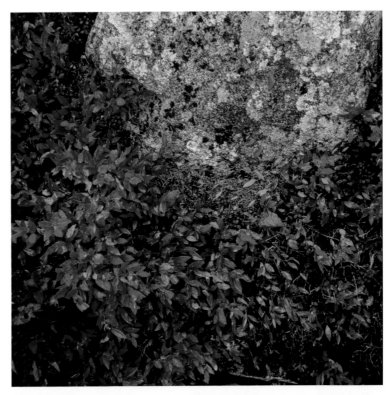

Image 3.25 (right). Blueberries. Acadia National Park, ME. Hasselblad 501 CM with Distagon 50mm FLE f/4.0 lens. Exposure: Provia RDP II 100 at ¹/₂ second and f/16. Tripod-mounted camera. **Image 3.26** (below). Leaf and lichen. Acadia National Park, ME. Canon EOS 7D with 28–135mm f/3.5–f/4.5 lens at 85mm. Exposure: ISO 100 at ¹/₁₅ second and f/16. Tripod-mounted camera.

Image 3.25 (top). Cardinal photographed from a blind, original. **Image 3.26** (bottom). Photo in production. **Image 3.27** (facing page). Digitally retouched. Burrell Township, PA. Minolta 9xi with a 1.4x converter and Minolta 300mm APO f/2.8 lens. Exposure: Provia RDP II 100 at $^1/_{125}$ second and f/4. Tripod-mounted camera.

it from. Flipping it did not change the lighting angle. I erased the small branch at the bottom and placed it over the broken part. I used Photoshop's Warp tool to stretch it into the exact shape I needed. Finally, I used the Clone Stamp tool to blend the two pieces together.

Look at the final image on page 47. Note what a significant difference a small change in a compositional detail can make. Sure, this fix was done digitally, but the takeaway here is that every aspect of your image plays into the overall composition. Carefully review the scene through your viewfinder to ensure that everything is just right before you take the photograph. The few minutes you spend studying your composition before shooting may save hours of retouching later.

With some postproduction work complete, I was left with a textbook example of a photo of a male cardinal with no distractions. *(Note:* If desired, I could crop in on the bird and make this a vertical-format image.) In this day and age, lots of things can be fixed in postproduction, but it all takes time.

your eye to the right? The shadow becomes the secondary subject against a monochromatic background. Let's review a photo reconstruction of red and white competing as a subject.

In the cardinal photo, the red and white conflict. I liked this photo of the cardinal with a nondescript background, but the broken branch was too much of a distraction for me. I felt that eliminating the broken part of the branch would improve the image. To accomplish that task, I cut out a section of branch, then flipped it horizontally so that the new section of branch would not look exactly like the section I cut

Key Skills in This Chapter:

1. The power of lines in guiding the eye through the image.

2. Taking advantage of implied lines for a stronger composition.

3. Engaging the eye with S curves.

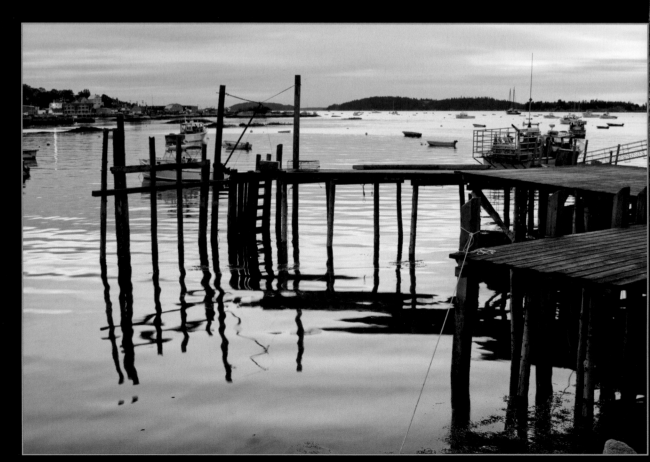

Image 4.1. Stonington Harbor, ME. Canon EOS 7D with EF 14mm f/2.8L USM lens. Exposure: ISO 100 at ⅛ second and f/8. Tripod-mount-

Line

Two-Dimensional Lines

Lines, whether implied or visually apparent, draw the viewer's gaze across the composition. They are an important aspect of designing an effective and engaging image.

In **image 4.2** and **image 4.3**, the linear movement is due to one dominant rectangular shape. The eye is drawn into the image at the lower-left corner and follows the shape of the subject from the lower left to the top-right corner of the frame—and back once again to the starting point. There is just one dominant two-dimensional line in this particular image.

Other images feature multiple linear forms that coax the gaze to move across the photo.

Image 4.2 (top) and **image 4.3** (bottom). Signs of spring. Burrell Township, PA. Canon EOS 30D with 28–135mm f/3.5–f/4.5 lens at 60mm. Exposure: ISO 400 at $^1/_{1000}$ second and f/4.5.

Image 4.4 (left) and **image 4.5** (below). Sand. Acadia National Park, ME. Arca Swiss F-1 with Schneider 210mm f/5.6 lens. Fuji RDP II 100 at ¹/₃₀ second and f/8.

Image 4.6 (left) and **image 4.7** (above). Frost. Burrell Township, PA. Canon EOS 30D 28–135mm f/3.5–f/4.5 lens at 75mm. Exposure: ISO 400 at ¹/₁₀₀₀ second and f/5.6.

In **image 4.6** and **image 4.7**, there are multiple linear patterns. In close-up photography such as this, it is difficult to establish depth. The lack of depth produces a flat, two-dimensional look.

In **image 4.9**, the hard edge and contrast in the lower-right corner is the focal point of the photograph. From there, the edges of the leaf draw your attention outward in multiple directions. This is due to the pronounced red edges against the light-blue sky. Note how this effect is lost in the black & white display key (**image 4.8**)—your eye is attracted to the dark shape in the lower-right corner. With very little contrast throughout the rest of the photo, your eye has no place to go.

In photographs such as these, the movement will always remain parallel to the surface of the image. In a classic landscape, the viewer is allowed to visually travel into the picture box. This is the three-dimensional movement we will discuss in the next section.

Image 4.8 (right) and **image 4.9** (below). Red oak leaf. Vandergrift, PA. Canon EOS 30D with 28–135mm f/3.5–f/4.5 lens at 115mm. Exposure: ISO 400 at $^1/_{1000}$ second and f/5.6.

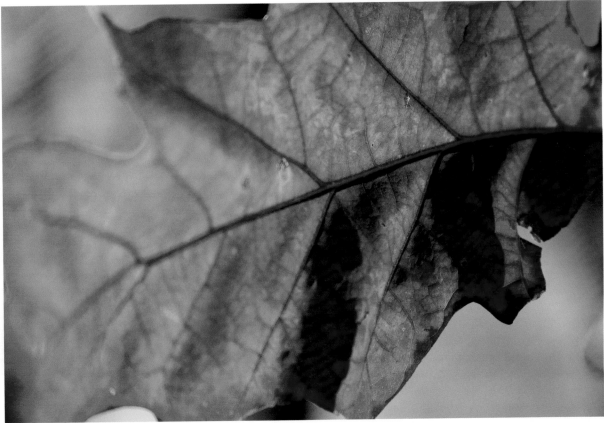

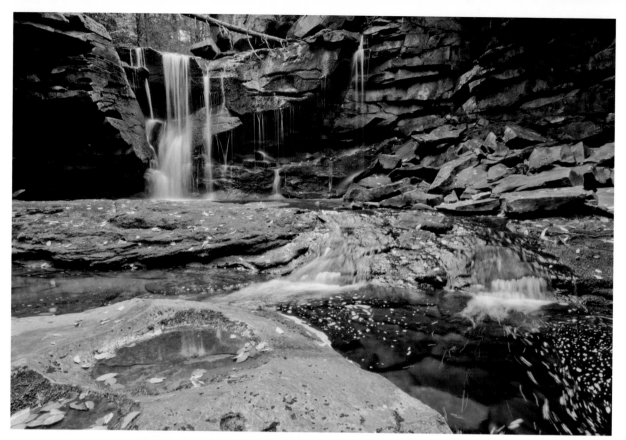

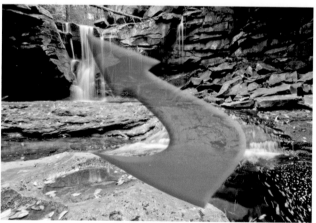

Image 4.10 (above) and **image 4.11** (left). Elakala Falls. Blackwater Falls State Park, WV. Canon EOS 7D with EF-S 10–22mm f/3.5–f/4.5 USM lens at 12mm. Exposure: ISO 100 at $1/2$ second and f/22. Tripod-mounted camera.

Three-Dimensional Lines

In **image 4.10** and **image 4.11**, a path is created from the foreground rock in the lower-left edge of the image to the top of the falls. This is due to the light tonal values of the rock and white water. A slow shutter speed renders the moving water white.

The dark cliffs on each side of the falls help emphasize and enhance the path. Once your eye travels to the top of the falls, the edge of the foreground rock and dark water draw your attention back to the beginning.

A close look at the pool of water upon the foreground rock reveals the reflection of the waterfalls. Using an ultrawide-angle lens required careful placement of the camera to capture all of these compositional elements and effects together.

My photographic adventures include more than twelve trips to Acadia National Park and the Bar Harbor area. The granite cliffs and

crashing ocean waves always offer new and unique photo opportunities. Visiting this area at different times of the year provides even more options.

Image 4.12 was captured during one of my few trips during the winter months. I arrived the day after a 12-inch snowfall. The blanket of white gave me a whole new perspective on my composition.

I took the photo toward the end of my stay because I wanted to focus on the multicolored shoreline. The warmer temperatures and the crashing waves had drastically reduced the amount of snow, and the low tide increased the amount of exposed granite.

The dynamics of this image would be utterly different if the shoreline had been covered with snow. In that case, we would have had a light-valued

foamy sea and a white-covered shoreline. The dark tree line would have drawn the eye because it would have been the only dark object in the photo. By waiting until the conditions were right, I was able to make the multicolored shore the focal point of the image, as intended.

The exposed low-tide shoreline forms a C shape (see **image 4.13**). Your eyes are drawn to the foreground rocks, and your gaze continues to move in a clockwise direction to the upper right-hand corner. The dominant shapes of the rocks in the foreground bring you back to the front of the scene, continuing the clockwise movement.

Image 4.12 (right) and **image 4.13** (below). Monument cove. Acadia National Park, ME. Arca Swiss F-1 with Schneider 90XL f/5.6 lens. Exposure: Provia RDP II 100 at ¹/₁₂₅ second and f/5.6. Tripod-mounted camera.

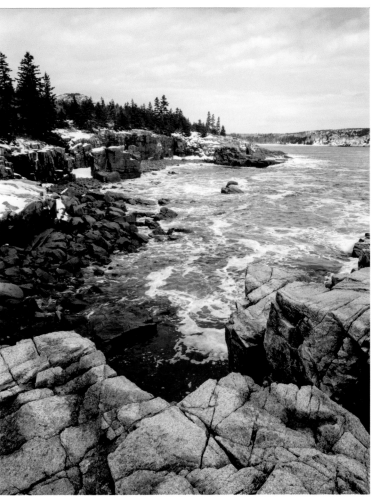

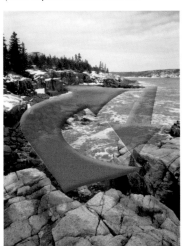

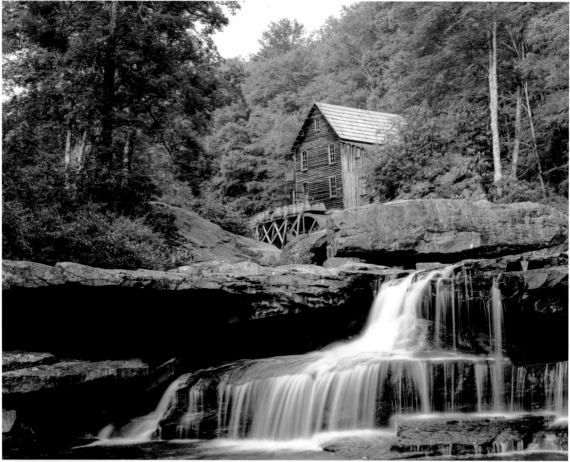

Image 4.12 (above) and image 4.13 (left). Grist mill. Babcock State Park, WV. Arca Swiss F-1 with Schneider 90XL f/5.6 lens. Exposure: Provia RDP II 100 at ¹/₁₅ second and f/22. Tripod-mounted camera.

West Virginia State Parks list this grist mill (**image 4.12** and **image 4.13**) at Babcock State Park as one of the most photographed in the country. The rocks and building provide many of the compositional requirements I look for when taking photographs—losts and founds (see pages 73–74), overlapping planes, and color unity, just to name a few.

Here, the three-dimensional movement is slightly different from what was shown in previous photos. The waterfall is the first shape to draw the eye. From there, the gaze moves up and over the rocks to the space behind the mill. This is due to the strong edge on the left side of the building.

Three-dimensional movement creates the feeling of being able to walk into the scenery.

Your path through the scene should be obvious enough so as not to confuse the viewer. With that said, not everyone will choose the same path.

Converging Lines

Lines are said to converge when they start off with a space between them but gradually move closer together and eventually meet. In images, train tracks are a common example of converging lines. In the foreground of the image, the rails are somewhat far apart. As the lines extend backward, the space between the rails seems to narrow. The end point of those merging lines is the focal point in the image. This is a strong compositional tactic for moving the eye through the image. Tracks that bear to the left or right suggest a still more interesting journey.

Image 4.14 (right) and **image 4.15** (below). Pemaquid Point Light, ME. Canon EOS 7D with EF 14mm f/2.8L USM lens. Exposure: ISO 100 at ¹/₁₂₅ second and f/11.

Image 4.14 and **image 4.15** contain numerous converging lines that lead to the lighthouse. This photo required much planning. I chose a 14mm ultrawide-angle lens to get the shot. When using this lens, moving your camera as little as 12 inches will dramatically change your composition. The gold rocks in the lower left-hand corner were only 1.5 feet from the lens.

In this scene, the converging lines—and the place they lead to—are obvious.

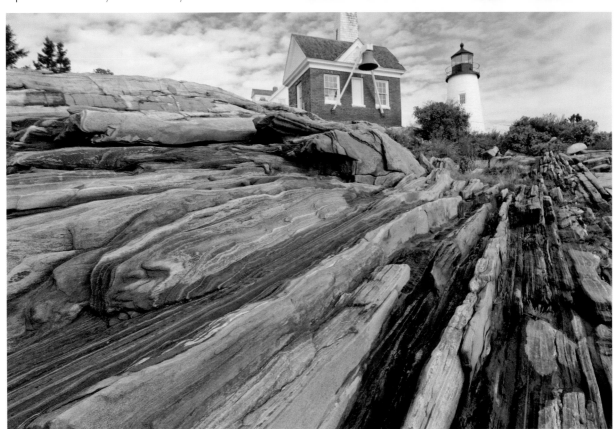

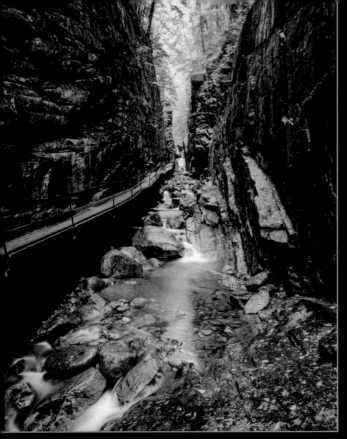

Image 4.16 (left) and image 4.17 (above). The flume. Franconia Notch State Park, NH. Arca Swiss F-1 with Schneider 90XL f/5.6 lens. Provia RDP II 100 at 4 seconds and f/16. Tripod-mounted camera.

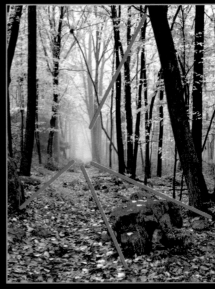

Image 4.18 (left) and image 4.19 (above). Fall color. Bear Rock State Park, PA. Arca Swiss F-1 with Schneider 90XL f/5.6 lens. Fuji RDP II 100 at 4 seconds and f/16. Tripod-mounted camera.

Image 4.16 and image 4.17 show several sets of parallel lines that converge to a point about two thirds up from the bottom of the photo. The slow shutter speed enhances the soft white water in the lower-left corner. This contrast was meant to pull your gaze back to the front of the photo.

In image 4.18 and image 4.19, the path leads off into the fog. The trees on the right and left create planes that converge toward the fog.

No matter what the subject is, converging lines play a large part in creating three-dimensional movement. This element of composition is one of the most powerful you can use to emphasize depth and direction.

Our next two pairs of images (image 4.20 and image 4.21, as well as image 4.22 and image 4.23, on page 58) illustrate the way that converging lines lead the viewer's gaze through the image. All of the lines are actually the edges

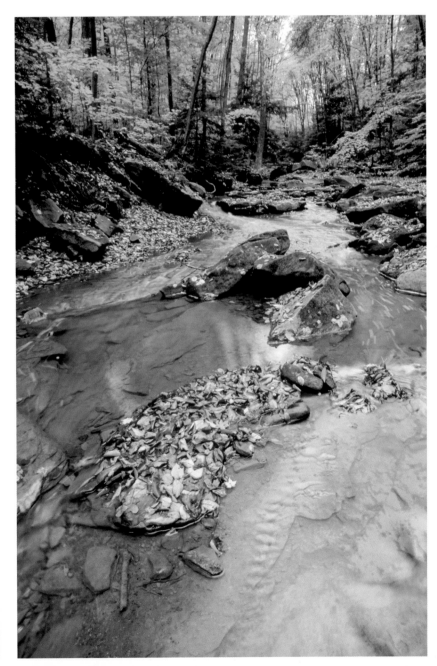

Image 4.20 (below) and image 4.21 (right). Roaring Run. Apollo, PA. Minolta 9000 with 28mm f/2.0 lens. Provia RDP II 100 at ¹/₄ second and f/16. Tripod-mounted camera.

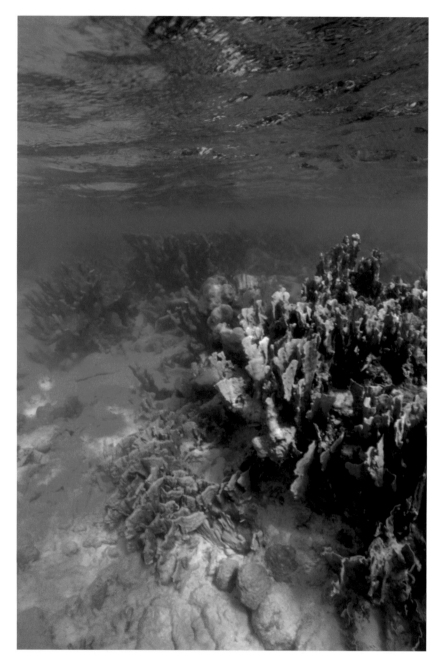

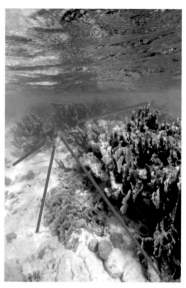

Image 4.22 (left) and **image 4.23** (above). Fire coral, photographed using available light only in Bonaire, NA. Nikonos V with Nikkor 15mm f/2.8 lens. Provia RDP II 100 at $^1/_{60}$ second and f/8.

of a particular plane. For example, the image of the fire coral features a shape that contains a strong vertical pattern. That shape creates two converging lines toward the left center.

There is a subtle difference between three-dimensional movement and the pinwheel and radial effect we will discuss later in this chapter.

Remember, one of the best ways to simplify an image is to squint your eyes. This will reduce everything to light and dark shapes.

Eye Direction

If you were to walk into a room and find a group of people staring at the ceiling, would you look up too? It is in our nature to try to see what others are seeing. This phenomenon comes into play in our images, as well.

If the subject in your image is looking to the left of the frame, your eyes will follow the implied line from their eyes to the point at which they appear to be looking. This compositional strategy is most effective when the eye direction of the subjects leads the viewer's gaze through the majority of the image, as this forces the viewer to look through the image as well. The problem is, the viewer's eyes will travel right out of the photo—and that's not what you're after. For this reason, you need to incorporate another element to pull the viewer's eyes back into your photograph.

In chapter 2, we saw the power that red and white have in an image. In **image 4.24**, I used those colors to keep the viewer engaged in the image. Although the couple is looking across the photo, the red flowers and white dress draw the viewer's gaze back into the image. The white birch trees slow the eyes' journey as you reach the end of the photo.

In **image 4.25**, the subject was seated in the shadow of the trees. The viewer's eyes follow

A Simple Test >>>

Is a particular element in your image contrasty enough to command attention? Test the contrast by using your peripheral vision. Consider the image of the turkeys. Concentrate on the space between the turkey on the right and the right-hand edge of the photo. Is there any shape, edge, or line on the left-hand side that attracts your attention?

Image **4.24** (top). Kawka Wedding. Northmoreland Park, PA. Canon EOS 30D 28–135mm f/3.5–f/4.5 lens at 65mm. Exposure: ISO 400 at $^1/_{500}$ second and f/16. Image **4.25** (center). Cody at Spruce Knob State Park, WV. Canon EOS 30D with 28–135mm f/3.5–f/4.5 lens at 28mm. Exposure: ISO 400 and $^1/_{125}$ second at f/16. Image **4.26** (bottom). Wild turkey photographed from a blind in Vandergrift, PA. Canon EOS 30D with 28–135mm f/3.5–f/4.5 lens at 135mm. Exposure: ISO 400 at $^1/_{125}$ second and f/16. Tripod-mounted camera.

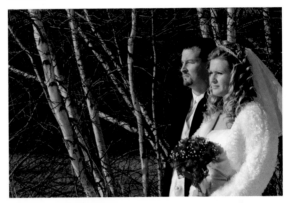

the subject's eye direction and move across the image from left to right. The trees' dark tones contrast nicely with the bright sky, and the contrast pulls the viewer back into the photo.

In **image 4.26**, the turkey on the right is looking out of the photo. This leads the viewer's gaze out of the image. The eyes are drawn back into the image by the bird on the left—there is significant contrast there and the left-hand turkey leads the gaze back to the right-hand bird. The eyes are forced to travel in a circular manner.

Controlling Parallel Lines

Parallel lines in an image can be created in a number of ways. Once present, the lines may dominate the image with a two-dimensional direction.

When one is trying to establish three-dimensional depth in an image, parallel lines act as a wall—so use this compositional element with caution. If not used correctly, they will direct the viewer's attention in an unwanted direction. Furthermore, if the size of the shape they create dominates the image, the shape may become the subject. As with all rules, these are meant to be broken. Portraying parallel lines as your subject should prove to be less of a challenge.

In **image 4.27**, the strong parallel lines are multidirectional, overpowering any three-dimensional movement. The black framework of the windows is unavoidable.

Image 4.27 (left). Reflection. Oakland, PA. Canon EOS 30D with 28–135mm f/3.5–f/4.5 lens at 95mm. Exposure: ISO 400 at $^1/_{1000}$ second and f/6.7. **Image 4.28** (top right). Cardinal photographed from a blind in Burrell Township, PA. Minolta 9xi with a 1.4x converter and Minolta 300mm APO f/2.8 lens. Exposure: Fuji RDP II 100 at $^1/_{125}$ second and f/4. Tripod-mounted camera. **Image 4.29** (bottom right). Lobster trap. Bernard, ME. Arca Swiss F-1 with Schneider 210mm f/5.6 lens. Provia RDP II ISO 100 at 8 seconds and f/32. Tripod-mounted camera.

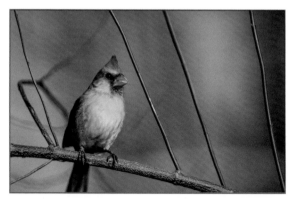

Image 4.30 (above) and image 4.31 (right). Paintbrush display. Class demo. Arca Swiss F-1 with Schneider 210mm f/5.6 lens. Provia RDP II 100 at $^1/_{60}$ second and f/16. Tripod-mounted camera and two White Lightning Ultra 1200s.

In **image 4.28**, a textbook photo of a female cardinal is overpowered by the two sets of parallel branches. Although the bird is looking out across the photo, your gaze is stopped by the up-and-down movement of the parallel branches.

In **image 4.29**, the slats form parallel lines that create a strong two-dimensional movement. I used several means to control the side-to-side movement. I included the edge of the trap on the left side. This stopped the two-dimensional movement completely on the left side. The rope helps slow down the movement on the right side. The upper-left side of the trap blends in with the background, creating three-dimensional movement.

Framing in tight, as was done in this image, will not allow for much perception of depth, but it is important to establish a foreground, middle ground, and background in the image. We will cover this in more detail on pages 69–70.

Everything in this photo appears as it did when I encountered the scene. I did not rearrange the objects. The buoy breaks all the like shapes and patterns to become the subject, and the ropes are under the snow. I did, of course, choose how the composition would be framed.

Pinwheel or Radial

The scene depicted in **image 4.30** and **image 4.31** contains various compositional elements. The one we are interested in is the pinwheel effect created by the brushes.

Although the brushes converge to a point, they are set up like a wagon wheel. Moving from one spoke to another creates a radial flow because of the positive spaces (the brushes themselves) and negative spaces (the void between the brushes).

In the next pair of example photographs (**image 4.32** and **image 4.33**), the tree trunks

mimic the shape of the wagon-wheel spokes, creating their own unique movement through the photo.

S Curves

The S-curve is often considered a feminine shape. Wedding photographers will pose a bride with these curves in mind. An S-shaped line can prompt an interesting visual journey through an image; however, it is a shape that can be difficult to spot in nature. You might find the pattern in a winding road or twisting creek. In the case of **image 4.34** and **image 4.35**, however, it was found in rock formations.

The vertical panoramic format of this image intensifies the S curve. Shooting this image during low tide made the S curve possible. Oth-

erwise, all of the dark rocks would have been under the water.

After careful study of the scene for **image 4.36** and **image 4.37**, I realized that it continued a double S curve, one atop the other.

To maximize this double S, I keep the vertical panoramic format used in the Bass Harbor image. This format crops into only what I want to show. This way, the S curves cover the majority of the image.

Note how the bridge blends in with the background but also how the parallel lines of the railings draw your attention to it.

Study your scene; it just may reveal an S curve or even two, which should provide a more dynamic journey through your image.

Image 4.32 (left) and **image 4.33** (above). Sunrise photographed from a canoe in Glades Project, West Sunbury, PA. Minolta 9000 with Minolta 28–85mm f/3.5–f/4.5 lens. Kodak KR 64 Kodachrome at $^1/_{60}$ second and f/5.6.

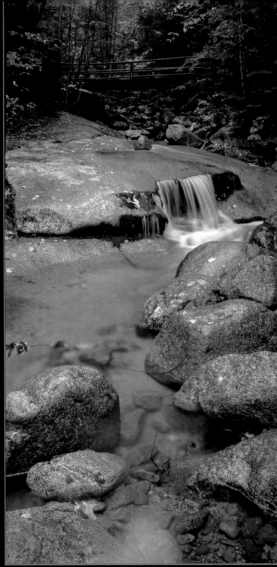

Image 4.34 (above) and image 4.35 (right). Bass Harbor Light, ME. Arca Swiss F-1 with Schneider 90XL f/5.6 lens. Horseman 6x12cm film back. Exposure: Provia RDP II 100 at ¹/₈ second and f/16. Tripod-mounted camera.

Image 4.36 (above) and image 4.37 (right). Near the flume. Franconia Notch State Park, NH. Arca Swiss F-1 with Schneider 90XL f/5.6 lens. Horseman 6x12cm film back. Provia RDP II100 at ¹/₂ second and f/16. Tripod-mounted camera.

Key Skills in This Chapter:

1. Blocking corners to keep the viewer engaged in the image
2. Defining the foreground, middle ground, and background.
3. Using the rule of thirds for dynamic compositions.

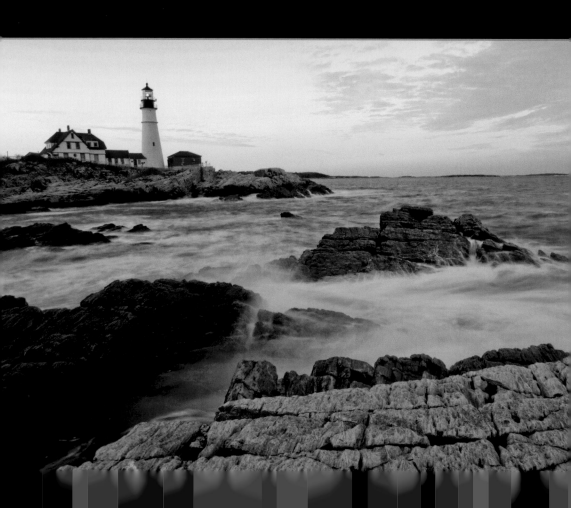

Arrangement

Blocking Corners

A well-planned composition will keep a viewer involved in your image. Elements such as color and contrast may grab someone's attention, but an established flow through the image will *keep* their attention.

In blocking the corners of a scene, you create a natural vignette that creates a never-ending circle within an image. There are two common ways to block a corner. A line such as the tree in the upper-right-hand corner of an image (see the Cherry Run image on page 121) or the edge of two contrasting shapes will create a blocked corner. **Image 5.2** and **image 5.3** feature contrasting shapes, the most common way to block a corner.

This element of composition may be one of the most important in establishing a flow. As long as each corner is blocked, the circle of flow will be complete.

In **image 5.4** and **image 5.5**, the edges of the hands and the black cuff block all four corners. Using the wedding dress as a background signifies a newly married couple. Their hands were

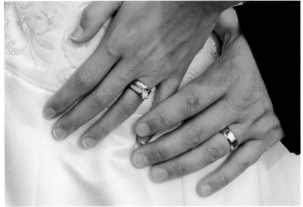

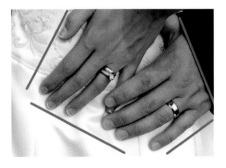

Image 5.2 (above) and **image 5.3** (right). Octopus. Bonaire, NA. Nikonos V with Nikkor 35mm f/3.5 lens and close-up kit. Ikelite SubStrobe 150. Exposure: Provia RDP II 100 at ¹/₆₀ second and f/16.

Image 5.4 (above) and **image 5.5** (right). Townsend wedding. Freeport, PA. Canon EOS 30D with 28–135mm f/3.5–f/4.5 lens at 60mm. Exposure: ISO 400 at ¹/₂₅₀ second and f/11.

placed to cover most of the embroidered detail and to keep the viewer's attention on the hands and rings.

In **image 5.6** and **image 5.7**, I placed one bearing on top of the other. This gave me the overall shape I wanted. Using only two parts left few options for creativity. I used the blueprint as the background, for an acceptable result.

Breaking the Horizon Line

By breaking the horizon line in two places, you can establish an entry and exit point to two different sides of an image. A typical example would be any landscape in which the horizon line is visible. However, this applies to any continuous line across your photograph that will divide it into two separate shapes.

In **image 5.8** and **image 5.9**, I used the tree and the fog as my two points. The tree in the foreground breaks the horizon line on the left side, and the fog softens the hard edge of the shore on the right.

The fog allows the transition from the shore to the sky, then your eyes move through the tree and back to the shore. The red arrows in the black & white photo illustrate the movement. Note how the lower corners are blocked with the rock formation and red blueberries.

Image 5.6 (left) and **image 5.7** (above). Bearing parts. Vandergrift, PA. Canon EOS 30D with 28–135mm f/3.5–f/4.5 lens at 60mm. Exposure: ISO 400 at ¹/₆₀ second and f/11. Tripod-mounted camera.

Image 5.8 (above) and image 5.9 (right). Near Monument Cove. Acadia National Park, ME. Hasselblad 501 CM with Distagon 50mm FLE f/4.0 lens. Exposure: Fuji NPH 400 at $^1/_{30}$ second and f/16. Tripod-mounted camera.

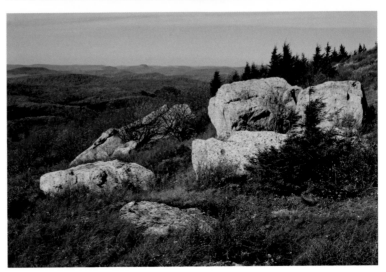

Image 5.10 (above) and image 5.11 (right). Spruce Knob, WV. Canon EOS 30D with 28–135mm f/3.5–f/4.5 lens at 28mm. Exposure: ISO 400 at $^1/_{750}$ second and f/11.

Because I broke the horizon line in two points, I did not need to block the top corners.

If there are enough elements of composition in the image, then breaking the horizon line once may be sufficient.

In image 5.10 and image 5.11, the horizon line is broken with only one point. Multiple ele-ments together may create more than one path to follow. Think of it as a journey through the forest. Each person may take a different path to arrive at the same destination.

When I conceptualize an image, I try to include as many different paths as possible. After careful study one path in particular may appear

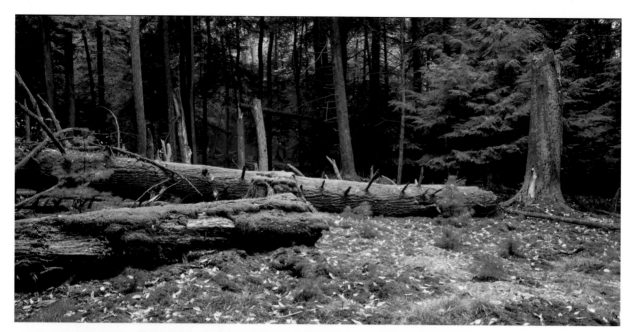

Image 5.12 (above) and image 5.13 (left). Cook Forest, PA. Arca Swiss F-1 with Schneider 90XL f/5.6 lens. Horseman 6x12cm film back. Exposure: Provia RDP II 100 at ¹/₁₅ second and f/11. Tripod-mounted camera.

dominant. This is the path on which I base my composition.

In the Spruce Knob image, there is a strong presence of overlapping planes formed by the rocks. This leads my eyes from the lower left to the upper right of the photograph, coaxing me to take in the trees and then the sky. While moving across the sky, is the white rock in the lower-left corner bold enough to pull your eyes back to the foreground? While squinting, do your eyes concentrate on the upper-left corner of the sky? You decide!

In image 5.12 and image 5.13, there is no sky or traditional horizon line, but there is a hard line across the image made by the fallen tree. To break up the line, I included the end of the tree on the right and, on the left, the young evergreen and limbs.

The stump on the right also directs your attention upward. If I had not broken this line, I would have a yellow-green half and a blue-green half with few elements to tie them together.

Image 5.14 illustrates an unbroken horizon line. Note how the hills appear to be floating.

Because the fog is unbroken, it divides the image into two sections.

Foreground, Middle Ground, and Background

A good photograph has a foreground, middle ground, and background. When these three areas are defined in the image, the photograph has a feeling of depth—a sense that there is a third dimension. This is the element of composition that places the viewer in the image. If you've ever heard the statement "I feel like I can walk right into that photo," this is the element that was used. Foreground, middle ground, and background will create the three essential planes necessary to establish a location.

As the viewer, you are standing in the foreground plane. Without a foreground, you may develop a sense of floating above the image. Including something that appears to be an arm's length away places the viewer in the image.

Image 5.16 shows a middle ground and background. Without a foreground, the viewer

must imagine where they are—on the shore, on a boat dock, or a patio of a beach house.

Image 5.14 (top right). Corn field. Brick Church, PA. Canon EOS 10D with 28–135mm f/3.5-f/4.5 lens at 28mm. Exposure: ISO 400 at $^1/_{125}$ second and f/11. Image 5.15 (bottom left) and image 5.16 (bottom right). Reflections. Camden, ME. Canon EOS 7D and EF 14mm f/2.8L USM lens. Exposure: ISO 100 at $^1/_{125}$ second and f/16.

Image 5.17 (above) and image 5.18 (left). Scenic. Camden, ME. Canon EOS 7D and EF 14mm f/2.8L USM lens. Exposure: ISO 100 and $^1/_{125}$ second at f/16.

The reflections tie the body of water in with the boats. There is plenty of detail and contrast to hold your attention, but none of these explains where you are located.

The foreground plane of **image 5.17** shows a dock in the lower-right corner. The boat in the lower left is large in scale, which makes it feel close. This foreground places the viewer on the dock directly next to this boat. To create a feel-ing of walking into a photo, a foreground is a must. Study **image 5.18**: the red area is the fore-ground, the yellow portion is the middle ground, and the blue section is the background.

To achieve this type of sensation, maximum depth of field will be needed. With a wide-angle lens, this would be f/11, f/16, or f/22—the aperture chosen will depend on the lens and focus point.

On a bright, sunny day you should have no problem with f/11, f/16, or f/22. With the Sunny 16 Rule (page 11), your camera will already be set to $^1/_{125}$ second at f/16 and ISO 100. On an overcast or cloudy day you may need to use a tripod if your shutter speed is below $^1/_{60}$.

Large, Medium, and Small

Large, medium, and small is exactly how it sounds. When working with more than one object of the same type, it is best to stagger their sizes, as illustrated by the icicles in **image 5.19**. In this shot, the icicles are staggered in size to prevent them from competing with each other. Note that changing your angle of view will help you to change the apparent size of the image elements.

In **image 5.20**, the Indian Pipe on the left is the large element, the three pipes in the middle lump together to form the medium element, and the two on the lower-left edge of the frame form the small element. I used the small to slightly overlap the medium to prevent the medium from becoming a second large shape.

Here, my angle of view was more specific. Imagine if I had shot the image more from the right side—the medium element would have completely overlapped the large one and made it small. When you are photographing small objects up close, camera placement can be critical. Moving your camera just a few inches either way can change your photo dramatically.

Image 5.19 (left). Freezing rain. Vandergrift, PA. Canon EOS 10D with 28–135mm f/3.5–f/4.5 lens at 135mm. Exposure: ISO 400 and $^{1}/_{180}$ second at f/5.6. **Image 5.20** (right). Indian Pipes. Linn Run State Park, PA. Canon PowerShot Pro1. Exposure: ISO 400 at $^{1}/_{30}$ second and f/2.8.

The Rule of Thirds

The rule of thirds is probably the most commonly used element of composition. To use the rule, imagine that there are two vertical lines at $^1/_3$ points and two horizontal lines at $^1/_3$ points across your image (**image 5.21**). The points at which these lines intersect (red dots) are called power points. They are considered ideal locations to position your subject.

This rule can be applied to photographs in either the horizontal or vertical format. Take a quick glance at **image 5.22** and you will find the leaf in the lower-right corner. There are two converging lines that lead you to the leaf, but the white spots on the bark are bold enough to pull you away, only to return to the leaf.

In this image, the leaf is placed in a lower corner for a reason. Because all lines are pushing down, the leaf is at rest. This will create a relaxed mood. If the leaf were high in the photo, a sense of tension would be established. It would appear that the leaf had a long way to fall before coming to rest on the ground.

Think of it this way: when the subject is in the lower two points, the viewer looks down on it. There is a settled and weighty feeling established. If the subject is placed at one of the upper power points, the objects will appear to be pushing or lifting upward, as if they are on a pedestal.

When photographing Cape Hatteras Light (**image 5.23**), I placed my camera high on the tripod. Why? The high position of the camera keeps the middle-ground vegetation below the top of the lighthouse. This way, the lighthouse has a towering effect over the rest of the photo.

Image 5.21 (top). The rule of thirds. The circles represent the power points, the best areas for subject placement. **Image 5.22** (center). Fall leaf. Acadia National Park, ME. Canon EOS 7D with 28–135mm f/3.5–f/4.5 lens at 75mm. Exposure: ISO 100 at 2 seconds and f/22. Tripod-mounted camera. **Image 5.23** (bottom). Cape Hatteras Light, NC. Arca Swiss F-1 with Schneider 210mm f/5.6 lens. Exposure: Provia RDP II 100 at $^1/_{60}$ second and f/16. Tripod-mounted camera.

Image 5.24 and image 5.25. Late snow. Vandergrift, PA. Canon EOS 10D with 28–135mm f/3.5– f/4.5 lens at 127mm. Exposure: ISO 400 at $^1/_{125}$ second and f/5.6.

Imagine driving toward any large city with skyscrapers. Long before the city limits are reached, you see the tops of the buildings. This is the effect I wanted to create.

Although I was nearly a mile away from the lighthouse, it was still quite visible. This photo was shot before they moved the lighthouse farther inland. Now it is next to impossible to get the ocean and the lighthouse in the same photo.

The overcast sky gives the sand a deeper color, and there is an S curve present. Using the rule of thirds allows opportunities for other elements of composition to be used.

Losts and Founds

The use of losts and founds will tie the objects in your image together and create a three-dimensional movement. A "lost" is an area in your image where two different objects blend together; a "found" is a hard edge caused by a dramatic color or value change.

Losts and founds are important to avoid that "cut-out-and-pasted-down" look. Imagine cutting a simple five-point star out of blue paper

and placing it on white paper. The entire perimeter of the star would be a "found" without a "lost." The blue star placed on white paper will lack three-dimensional movement. Obviously, if you want strong immediate attention to a subject, eliminating the lost elements on the perimeter would be necessary.

Image 5.24 is an image with losts and founds. The background is an out-of-focus snow scene. This makes the snow on top of the maple leaves very close in value to the background tones. This is the lost area of the image. The dark-green areas of the leaves that are against the background create a hard edge. These are the found areas of the image.

Note: In this section, the black & white key photo above (**image 5.25**) and on page 74 (**image 5.27**) have their own color code. Blue arrows show the lost areas of the image and the red lines indicate the founds.

Image 5.26 contains a multitude of losts and founds. The driftwood and rocks feature similar colors. Anywhere the two objects overlap, a lost is created. Each one of the bright edges of the

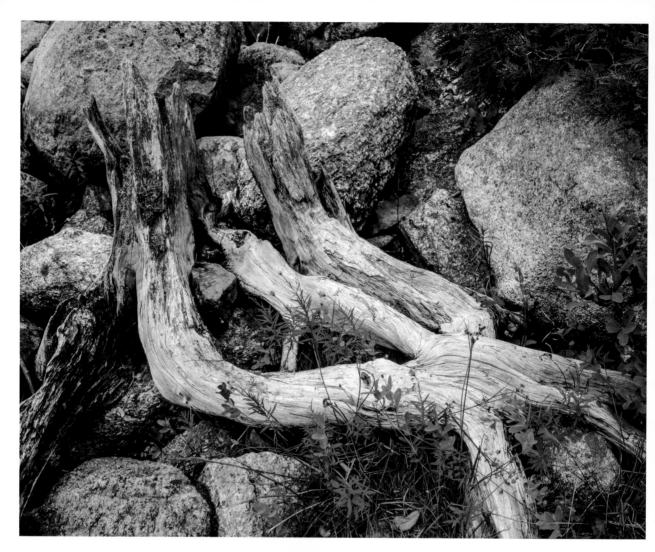

Image 5.26 (above) and **image 5.27** (left). Driftwood. Jordan Pond, Acadia National Park, ME. Arca Swiss F-1 with Schneider 210mm f/5.6 lens. Exposure: Provia RDP II 100 and ¹/₂ second and f/16. Tripod-mounted camera.

driftwood and rocks creates a found against the dark shadowed areas.

Looking at the black & white photo key, note how the red lines create a circular shape. The largest found edge appears to be the lower-left corner of the driftwood. The more textured upper-left corner of the driftwood blends in rather well with the rocks.

Image 5.28 (top). Moose. Sandy Stream Pond, Baxter State Park, ME. Minolta 9xi with a 1.4x converter and a Minolta 300mm APO f/2.8 lens. Exposure: Provia RDP II 100 and $^1/_{500}$ second at f/8. Monopod-mounted camera. Image 5.29 (bottom). Buck photographed from a blind in Vandergrift, PA. Canon EOS 30D with 28–135mm f/3.5–f/4.5 lens at 28mm. Exposure: ISO 400 at $^1/_{250}$ second and f/5.6. Tripod-mounted camera.

Choosing the Format

How do we choose the image format (horizontal or vertical), and why is it so important?

Choosing the format that best suits the physical orientation of the subject will eliminate dead space. For example, when a full-length portrait is created using a horizontal image format, there is a lot of empty space on the left and right sides of the subject. A portrait composed in a vertical format allows for a larger subject size and less dead space. This sounds like a basic strategy, but what we are trying to do is capture an image that requires as little postproduction work as possible. This includes cropping. Sure, cropping can be done in a pinch. However, you may be dramatically decreasing the digital file size of your image, which will limit enlargement options later.

In image 5.28 and image 5.29, the animals gave me plenty of time to decide on my format.

I chose the vertical format in order to best show the moose in its natural environment. Also, the antlers in early summer would not add much impact to a "cropped in" photo.

On the other hand, the buck owns an irregular rack and deserves a closer look. This is why I chose the horizontal format and cropped in on its body.

In **image 5.30** and **image 5.31**, the butterflies are much more "flighty," so I had to anticipate their movements before taking the photo.

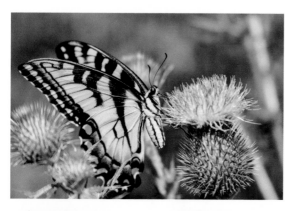

In the two splash photos (**images 5.30** and **5.31**), the subject is ever changing. As a large wave goes out, another comes in over top of it. The direction of the turbulent water had a direct effect on the way the waves crashed. There were many factors to consider in anticipating the shape and angle of the waves.

Having a selection to work with is the key here. Out of dozens of shots, I picked these to represent the crashing waves. Most of the other shots were acceptable, but each had some subtle issues. In **image 5.32**, I liked the cerulean-blue shadowed areas of the water. **Image 5.33** has a boomerang shape that takes you back to the upper-left corner.

Trying to capture this type of subject matter is where digital media and a fast CPU pays off. You can capture many experimental shots, free of charge! Using film, shooting away to get a few good crashing-wave shots would have been costly.

For my last comparison of format (**image 5.34** and **image 5.35**), I shot the dories pretty much the same way. Shooting both formats will ensure that I have a vacation image that will work on any wall in my house. Also, the two formats have a subtle difference in their story-telling. The horizontal format places the viewer inside the foreground dory, whereas the vertical presentation places the viewer beside it.

The vertical format would suit a magazine cover layout and would probably be the only format an editor would accept. The horizontal format would be better suited as a fine-art print above the couch. Obviously, this line of thinking applies to any given subject matter.

Image 5.30 (top). Tiger and thistle. Burrell Township, PA. Canon EOS 10D with 28–135mm f/3.5–f/4.5 lens at 127mm. Exposure: ISO 400 at $^{1}/_{1000}$ second and f/8. **Image 5.31 (bottom).** Spicebush. Vandergrift, PA. Canon EOS 10D and 28–135mm f/3.5–f/4.5 lens at 135mm. Exposure: ISO 400 at $^{1}/_{1000}$ second and f/8.

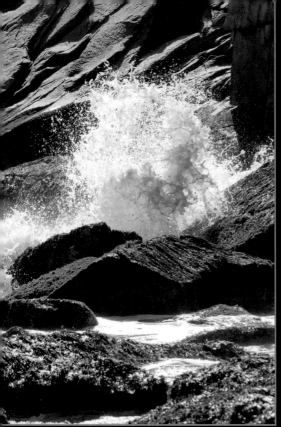

Image 5.34 (top). Dories (horizontal). Stonington, ME. Canon EOS 7D with EF 14mm f/2.8L USM lens. Exposure: ISO 100 at $1/125$ second and f/8. Image 5.35 (bottom). Dories (vertical). Stonington, ME. Canon EOS 7D with EF 14mm f/2.8L USM lens. Exposure: ISO 100 at $1/125$ second and f/8.

Image 5.32 (top). Splash, vertical. Sand Beach, Acadia National Park, ME. Canon EOS 7D with EF 70–200mm f/2.8L USM lens at 165mm. Exposure: ISO 400 at $1/1600$ second and f/8. Image 5.33 (bottom). Splash (horizontal). Sand Beach, Acadia National Park, ME. Canon EOS 7D and EF 70–200mm f/2.8L USM lens at 165mm. Exposure: ISO 400 and $1/1600$ second at f/8.

Image 5.36 (above). Sunset. Bonaire, Dutch Antiles. Minolta 9xi with 28–85mm f/3.5–f/4.5 lens at 28mm. Exposure: Provia RDP II 100 at ¹/₄ second and f /11. Tripod-mounted camera. Image 5.37 (left). Neese/Negley wedding. Butler, PA. Canon EOS 10D with 28–135mm f/3.5–f/4.5 lens at 95mm. Exposure: ISO 400 at ¹/₃₅₀ second and f/5.6.

Framing the Subject

Framing your subject in a natural way will enhance the foreground, middle ground, and background effect. When photographing, I often look for unique props to help tell the story.

In **image 5.36**, incorporating silhouettes of the palm trees enhanced the tropical atmosphere. Placing a small patch of palms in an upper corner would have been acceptable, but I was moved by this particular sunset and wanted to create a more inviting approach. Surrounding the entire sky with palms created a sort of "doorway" that places the viewer under the palms on the beach.

Image 5.37 was shot after my clients' wedding ceremony. The couple was on their way to the reception, and I took this shot just before they jumped into their classic car. I shoot an average of 800 photos per wedding; this gives the bride and groom many experimental, creative,

and well-composed shots from which to choose. I've found that the compositional needs and opinions of each couple vary tremendously.

A couple may frown upon specific shots. I try to convince them that their parents or other family members may not feel the same way. After all, wedding shots are shared by all who are involved. Everyone may be looking for something different.

In **image 5.38**, I used the glass panels in the door to frame the buoys. Squint your eyes to break down this image. The door pretty much blends in with the rest of the building. The most dominant shapes are the three black glass panels at the top of the door.

As soon as the black space grabs your attention, it quickly reveals the buoys. The black-and-orange rope I placed in the lower-left corner of the frame creates a subtle balance to the windows and buoys.

The sunny conditions kept the building exterior bright, which in turn gives the black interior more impact. If this image were captured on an overcast day, the interior and exterior color value would have been much less contrasty.

At a quick glance, this could be the door to any building. The lobster trap buoys makes it unique.

Image 5.38. Lobster trap buoys. Bernard, ME. Arca Swiss F-1 with Schneider 90XL f/5.6 lens. Horseman 6x12cm film back. Exposure: Provia RDP II 100 at 1/30 second and f/16. Tripod-mounted camera.

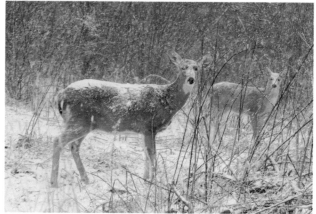

Image 5.39 (left). Sunrise at Glades Project, photographed from a canoe in West Sunbury, PA. Minolta 9000 with Minolta 28–85mm f/3.5–f/4.5 lens. Exposure: Kodak KR 64 Kodachrome at $^1/_{60}$ second and f/5.6. Image 5.40 (top right). Oak leaf. Acadia National Park, ME. Canon EOS 7D and 28–135mm f/3.5–f/4.5 lens at 85mm. Exposure: ISO 100 at $^1/_6$ second and f/18. Tripod-mounted camera. Image 5.41 (bottom right). Snow storm. Vandergrift, PA. Canon EOS 10D with 28–135mm f/3.5–f/4.5 lens at 135mm. Exposure: ISO 800 at $^1/_{180}$ second and f/8.

Secondary Subjects

Including a secondary subject in the image frame will help tell your story. Think of a secondary subject as the supporting actor. In any well-written movie, the supporting actor will reinforce the theme behind the star of the movie. In a still image, the secondary subject will do the same. Two subjects that complement each other will create movement in your image.

In **image 5.39**, the primary subject is a lone goose in the mist. The sun is a secondary subject that creates a diagonal line through the composition. The mist tones down the sun—it

is there, but it's not overpowering. The goose and the sun are two entirely different subjects that make up this photo.

In **image 5.40**, the two subjects are more closely related. The pin-oak leaf and the acorn tell the story of an oak tree nearby. The white birch branch covered by lichen has evidently been there for a while. These objects speak of a forest made up of white birch and oak trees at the very least. However, since the white birch blends in rather well with the lichen, the oak leaf and acorn become the primary and secondary subjects.

At first glance, **image 5.41** shows a lone doe riding out a storm. If you take a closer look, you will find a second doe behind it. In this photo, the main subject and secondary subject are both deer.

There are times when a group of deer standing close together can be considered a single subject. The outline of the group becomes more dominant than any one deer. This, of course, would work with any type of object.

In the snow storm photo, the doe in the background is not as obvious as the foreground doe; the less-prominent deer establishes itself as a secondary subject.

Triangular Shapes

A triangular arrangement creates a continuous flow in your composition. In portrait photography, a triangle shape helps to contain the gaze in the intended area of the photo, much like a circle or a vignette. You can create this triangle by controlling the light and dark areas of your subjects or through posing. The perimeter of the subject is what we will focus on.

In **image 5.42** and **image 5.43**, my subject, Megan, posed her arms and head to create a triangular shape that is upright on its base. Working with a triangle may also prove to be a more effective way to use space.

Image 5.42 (above) and **image 5.43** (right). Megan. Vandergrift, PA. Canon EOS 30D with 28–135mm f/3.5–f/4.5 lens at 70mm. Exposure: ISO 400 and $\frac{1}{60}$ second at f/8.

Image **5.44** (left) and **image 5.45** (above). Emit and Dana. Vandergrift, PA. Canon EOS 10D and 28–135mm f/3.5–f/4.5 lens at 125mm. Exposure: ISO 800 at ¹/₆₀ second at f/8.

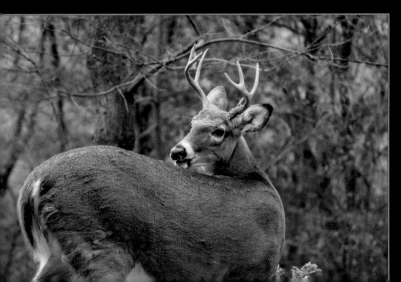

Image **5.46** (left) and **image 5.47** (above). Buck. Vandergrift, PA. Canon EOS 10D with 28–135mm f/3.5–f/4.5 lens. Exposure: ISO 800 at ¹/₉₀ second at f/5.6.

In **image 5.44** and **image 5.45**, the corsage plays a key role in establishing the triangle. In this photo, I carefully chose the angle of my light, observing what was illuminated and what fell into shadow. Without the corsage, the jacket would create dead space in the entire lower-right corner.

As shown in **image 5.46**, animal portraiture will also lend itself to the triangle. The position of the buck's head creates a more compact perimeter, unlike the typical profile of a deer.

Placing your subjects in a triangular configuration will also impact your background and/or negative space. In these example images, the triangle is the dominant shape.

Tangents

Suppose that during the holidays you wanted a family photo in front of your fireplace. Once everyone is in place, the photos are taken. Then, looking back through the photos, you find that one of your relatives appears to have a flower pot sitting on top of his head. That was the flower pot that always sits on your fireplace mantel. What happened?

If the bottom of the pot shares a line with the top of the subject's head, it will appear flattened into the same plane. This concept is illustrated in **image 5.48**. The red square is behind the blue square. Because the squares share a line, it is difficult to distinguish which shape is in front of the other. **Image 5.49** shows a subtle adjustment of the blue square. We can now see that the blue square is in front of the red square, and there is no confusion between the two shapes.

In **image 5.50**, the branch in the background appears to be sitting on top of the bird's head and back. The branch shares a line with the bird; therefore, the two objects appear to be on the same plane. This results in visual confusion.

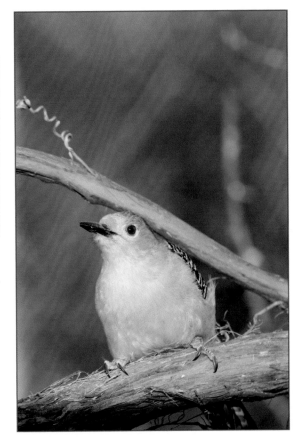

Image 5.48 (above left). **Image 5.49** (above right). **Image 5.50** (right). Red-bellied woodpecker, photographed from a blind in Vandergrift, PA. Canon EOS 7D with a 1.4x converter and 70–200mm f/2.8 lens. Focal length 280mm. Exposure: ISO 400 at $^1/_{160}$ second and f/8. Tripod-mounted camera.

Image 5.51 (left). Machias Light, photographed from a boat near Machias Island, ME. Original capture. Minolta 9xi and Minolta 28–85mm f/3.5–f/4.5 lens. Exposure: Provia RDP II at $^1/_{500}$ second and f/8. Image 5.52 (below). Machias Light final image, after digital retouching.

In **image 5.51**, note how the wave runs into the edges of the cloud. This photo may be acceptable as is, but with a little bit of retouching, we can create a better final image.

In the digitally retouched photo (**image 5.52**), the cloud and the wave no longer blend together into one plane. The wave is more distinct, and the cloud even appears to be pushed back some. This is the before-and-after effect of eliminating a tangent between two objects.

As stated before, compositional rules can be broken for effect. There may be a time when you want two objects to appear on the same plane for artistic reasons. If so, you will have to create a shared line between the two objects.

Text

The power of text in an image cannot be ignored. It can be stronger than even red and white objects (discussed in chapter 3). Why?

Image **5.53** (top). Antiques. Mount Desert Island, ME. Canon EOS 7D with 28–135mm f/3.5–f/4.5 lens at 65mm. Exposure: ISO 100 at ¹/₁₅ second and f/18. Tripod-mounted camera. **Image 5.54** (center). Ellen Marie. Bernard, ME. Canon 7D with 28–135mm f/3.5–f/4.5 lens at 65mm. Exposure: ISO 100 and ¹/₂₀₀ second at f/8. **Image 5.55** (bottom). Migley wedding. Cranberry, PA. Canon EOS 30D with 28–135mm f/3.5–f/4.5 lens at 65mm. Exposure: ISO 1000 at ¹/₆₀ second and f/4.5.

We are constantly bombarded with visual information. For example, while driving, we constantly search for road signs that tell us the rules of the road and guide us on our journey. We've been conditioned to respond to text. It piques our curiosity, and we look to it for answers.

When you include text in your photos, be sure it is there for the right reasons. Capturing a family vacation photo next to the state park sign will show your viewers in an instant where you were last summer. When composing an image for an individual portrait subject, however, I often position myself to keep signs out of the background. With a single subject, text can be too distracting.

In **image 5.53**, the drugstore sign is hard to miss because it is bright-yellow text in a fairly dark image. But again, the point of a sign is to grab your attention. Remember, text has a cut-out-and-pasted-down look, and it breaks the "losts and founds" rule of composition.

In **image 5.54**, the text on the boats is very clear. The dark text against a white background becomes a focal point in this photo. Fisherman often name their boats after the first names of their children, resulting in names like "Ellen Marie" and "Sarah Adam." In this photo, the text is vivid and unobstructed.

When preparing to capture **image 5.55**, I noticed the interaction between the bride and maid of honor. To establish the location where

the interaction took place, I wanted to show the name on the window. I opted to shoot from an angle to blend the text into the reflection of the lights. As a result, parts of the letters are lost in the white of the lights. This created losts and founds that I would not have had otherwise. Since the window reflects what is inside the mall it serves as a natural filter. (This phenomenon will be discussed on pages 96–97.)

Natural Composition

When considering an artistic approach to arranging your subjects, it is very important not to fight the natural elements that may be present in your background. What do I mean by this? This means understanding what is happening within the boundaries of your image without an introduced subject. Are the lines leading to a specific point? Are there dominant shapes with eye-catching colors? Is there a lack of anything going on? It is important to take a few minutes to study the background to understand how best to place your subject.

In the portrait of Terek and Andrea (**image 5.56**), the bride and groom are on a staircase in the upper-right corner. It is the dark archway that creates the "found" against the white dress.

Also, the light-gray staircase frames the bride and groom against the darker foreground and background foliage.

There is a natural glow in the portrait of Kassie O'Neil (**image 5.57**) due to the lighting. It is not direct sunlight, but reflected light streaming through an opening in the tree canopy. I posed her against a dark background of moss-covered boulders and ferns to ensure that the eye is drawn to the brighter part of the composition, Kassie.

The photo of my mother, Sylvia Gallovich (**image 5.58**), is an example of natural composition. Without her, the rock would portray itself as the subject—so it was only natural to place her on the rock. The upper-right corner is blocked by the stone wall, while the upper-left corner is blocked by the angled branches. The dark greens and the rock block the lower left and right corners respectively. This vignette creates a pleasing flow with the water in the background.

In **image 5.59**, the white bridal dress demands attention. The bridge draws the eyes through the frame and toward the church in the background. The white dress brings the viewer's attention back to the beginning of the journey.

Image 5.56. Terek and Andrea. Wyndam Rose Hall, Jamaica. Hasselblad 501 CM with Distagon 50mm FLE f/4.0. Exposure: Fuji NPH 400 at $^1/_{500}$ second and f/16.

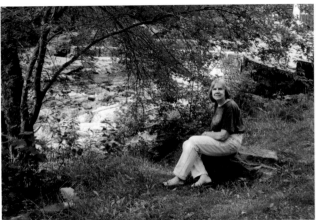

Image **5.57** (above). Kassie O'Neil. McConnells Mill State Park, PA. Canon EOS 30D with EF 70–200mm f/2.8L USM lens at 73mm. Exposure: ISO 800 at $^1/_{250}$ second and f/2.8. Image **5.58** (top right). Sylvia Gallovich. McConnells Mill State Park, PA. Canon EOS 10D with EF 28–135mm f/3.5–f/5.6 IS lens at 28mm. Exposure: ISO 400 and $^1/_{125}$ second at f/6.7. Image **5.59** (bottom right). Stone bridge. Grove City College, PA. Hasselblad 501 CM with Distagon 50mm FLE f/4.0 lens. Exposure: Fuji NPH 400 and $^1/_{125}$ second at f/11.

I wanted a foreground object of some kind; however, the river bank was not the answer. To keep with a specific color scheme, I chose not to include the light-green grass on the shore, which would have been in the foreground of the picture. For me, it would have created an un-wanted eye-catching yellow-green stripe at the bottom of the photo. The browns or golds of fall vegetation would have been the answer. The staggered shapes of wild brown plants would create a pleasing result as compared to a yellow-green stripe.

Key Skills in This Chapter:

1. Taking advantage of ambient light and using backlighting.

2. Incorporating atmospheric effects in your images.

3. Using filters, playing with patterns, and creating abstracts.

Image 6.1. Dynamics of a wave. Presque Isle State Park, Erie PA. Canon EOS 7D with a 1.4x converter and EF 70–200mm f/2.8L USM lens. Focal length: 280mm. Exposure: ISO 400 at $^1/_{1500}$ second and f/8.

Artistic Considerations

When you have fast-moving clear water reflecting the blue sky (**image 6.1**), the stage is set for a great shot. Unless you consider your artistic options (here, using a fast shutter speed), however, you might miss the opportunity to capture the crystalline shapes the moving water produces.

Ambient Lighting

Ambient light is "found light"—that which is available to you when you arrive at the scene. Midday sun, light reflected off of buildings, room lights, and light filtering through stained-glass windows is ambient light. Ambient light is ever-present, and taking advantage of it usually requires nothing more than a tripod.

Image 6.2 reveals a spotlight effect. Sunlight filtering through the trees illuminates only the lamp, while the corners of the photo fall into natural shadow.

Image 6.2. Lamp post. Oakland, PA. Canon EOS 30D with 28–135mm f/3.5–f/4.5 lens at 90mm. Exposure: ISO 400 and $^1/_{1000}$ second at f/6.7.

This effect is used often in a studio setting. It brings attention to the subject through the use of light. The high-contrast areas from the direct light form the focal point of the image. There is a dramatic difference between the hard edge of the lamp shadow and the soft edges of the tree shadows.

Image 6.3 illustrates the use of overhead lighting. It illuminates the bride and gives the stone wall its texture. The chandelier fills the space above the stone railing and provides a counterbalance to the bride. It is the combination of the two light sources that makes this photo complete. Without one of the light sources, I would have to rethink my photo and crop in.

In **image 6.4**, sunlight filtering through French doors backlit the scene. The colors and the reflective qualities of your subject will affect the way the scene is rendered. Here, the dinner setting is made up of whites and highly reflective silver, so the black silhouette look that backlighting typically produces is avoided.

When working with ambient light, the way that you crop the image may make all the difference between a photograph that works and one that doesn't. Eliminating the right amount of shadowed area will create a balanced composition. Carefully choosing a camera angle to make the best use of the light will also improve your results.

If you're unsure that you've captured the perfect shot, take many photos and give yourself options in the editing room. There you may learn what to consider the next time you're working in a similar ambient-light scenario.

Atmosphere

For our intents and purposes, atmosphere is considered any condition that would limit visibility such as fog, rain, snow, and smoke. Also, for those who have experienced it, steam from a city street vent in the winter can create a unique atmosphere.

Image 6.3 (top). Gazdag wedding. Pittsburgh, PA. Canon EOS 30D with 28–135mm f/3.5–f/4.5 lens at 28mm. Exposure: ISO 400 at ¹/₆ second and f/3.5. Tripod-mounted camera. **Image 6.4** (bottom). Dinner setting. LVCC Pittsburgh, PA. Hasselblad 501 CM Distagon 50mm FLE f/4.0. Exposure: Fuji NPH 400 and ¹/₆₀ second and f/8.

Image 6.5. Canon Mountain, NH. Arca Swiss F-1 with Schneider 90XL f/5.6 lens. Horseman 6x12cm film back. Exposure: Provia RDP II 100 at ½ second and f/11. Tripod-mounted camera.

Because I love the outdoors and natural settings, atmosphere is my most favorite photographic effect. I always keep my eyes open for such events. It could prove to be not only a rare occurrence but a powerful compositional tool as well.

Taking advantage of atmospheric elements can dramatically change your composition. How? By diffusing the background, it is much easier to choose what you want as the subject. To establish the subject in the image, simply keep the person or object closer to you.

The various visibility-reducing phenomena described above can each lend a very different mood to your images. Choose subject/atmospheric elements that work well together to create an interesting story.

This panoramic of Canon Mountain (**image 6.5**) was photographed in a heavy snowfall. I placed the skiers and the trail sign in the same plane. These would be the two objects most vis-ible in the image. The subtle shapes of the trees in the background complete the effect.

I take any opportunity to photograph atmospheric effects without hesitation. Returning to these same places later in the day may prove the mode and concept of the original image gone forever. Without limited visibility, there may be countless objects in the background that will dramatically change your composition. To avoid such clutter, limited visibility is the most effective tool.

Granted, there are tools such as fog filters, but I choose not to use them. They tend to place everything in the same plane, giving you the same amount of diffusion throughout the image. In natural fog, objects are diffused more toward the background and less in the foreground. Also be careful not to use a fog filter on a sunny day: you may establish the hint of a foggy day, but there are no shadows in heavy fog.

Image 6.6 portrays natural fog. Note how everything in the foreground is sharp and colorful. As you travel back into the tree line, the contrast begins to fade.

Image 6.7 was photographed just after the snowfall. After a heavy wet snowfall is the ideal time for photographing. Why? A heavy snowfall usually means a change in the weather, and that means wind. The snow on the trees is our atmospheric help.

Without the snow, the stark shapes of the dark trees become the dominant feature against the white background. In other words, losing the snow on the trees eliminates your losts and founds, leaving you with the overpowering shapes of the trees. With only the stark shapes of trees to work with, it would be a challenge to portray any other object in the landscape as the subject. In a black & white photo such as this, introducing color is the solution. Even in the distant background, a red ski jacket would create a subject that would dominate the trees.

Image 6.8 was shot during a heavy rainfall at twilight. The heavy rain provided the wet pavement with countless reflections that create the atmospheric effect, an excellent opportunity for color unity.

This type of photo would not be possible without the wet pavement and the timing of twilight. The ambient light illuminates the buildings and cars in an even fashion but does not overpower the night-time lights. Also, without the ambient light, this would prove a much more difficult exposure. The building and

Image 6.6 (top left). Near Crooked Creek. Brick Church, PA. Canon EOS 10D and 28–135mm f/3.5–f/4.5 lens. Exposure: ISO 400 and $^{1}/_{125}$ second at f/5.6. **Image 6.7** (right). Snow Storm. Vandergrift, PA. Canon EOS 10D 28–135mm f/3.5–f/4.5 lens at 135mm. Exposure: ISO 400 at $^{1}/_{350}$ second and f/5.6. **Image 6.8** (bottom left). Main Street. Bar Harbor, ME. Canon EOS 7D with EF 14mm f/2.8L USM lens. Exposure: ISO 100 at $^{1}/_{4}$ second and f/8. Tripod-mounted camera.

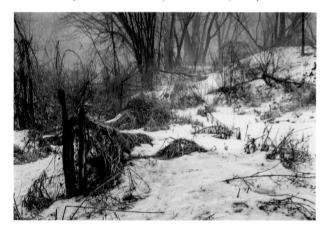

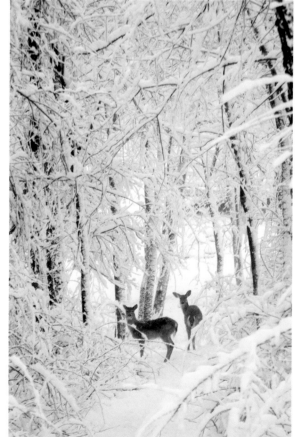

Image 6.9 (top). Wave in Presque Isle State Park, Erie, PA. Canon EOS 30D with 28–135mm f/3.5–f/4.5 lens at 135mm. Exposure: ISO 400 at $^1/_{500}$ second and f/5.6. Image 6.10 (bottom). Sunrise. Stonington, ME. Canon EOS 7D with 28–135mm f/3.5–f/4.5 lens at 135mm. Exposure: ISO 100 at $^1/_{80}$ second and f/8.

treetops would have fallen into black, and the lights would have been overpowering.

Backlighting

Backlighting is a dramatic effect; however, it usually proves to be a very difficult exposure. Aiming your camera into the light source will surely wreak havoc on the light readings. To get good backlighting results, there are a few guidelines we must consider.

First and foremost is the subject itself. Is it transparent or opaque? Transparent subjects such as waves crashing on the shore or stained-glass windows are relatively easy to

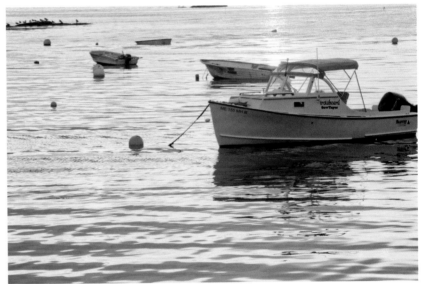

successfully backlight. These subjects refract light to illuminate themselves; therefore, you do not need to aim the camera straight into your light source, giving you a rather narrow latitude of light throughout your image. (Latitude refers to the range of light readings you may achieve throughout any given scene.)

In image 6.9, the wave was back-lit by a low-angled sun. The silty bottom of Lake Erie creates the amber color of the water. Because the wave is small, there is very little water to

filter out the light, thus giving the wave itself a luminescent look.

Photographing an opaque subject will prove to be more difficult. The end result will depend on the color of the subject and what is around it.

For example, the white boat in image 6.10 is rather dark. Why? In this photo, the water acts as a mirror, reflecting (not refracting) the sunlight directly into the camera. If I want to capture the colors of the sunrise, I will have to stop down my aperture, thus making the boat

a medium gray. If I opened up my aperture setting to render the boat white, I would burn out the colors of the sunrise. This photo is a typical example of a wide latitude of light; it is now the water itself that creates the difficult exposure. Thus, the surroundings of the subject will affect the result. Using the LCD screen on your digital camera reveals an accurate representation of the end result. This is worth noting because back when only film was available, experience was your only guide. LCD panels on the backs of cameras did not exist!

Image 6.11 shows white in a different way. Here, the bride's dress is acting like a large

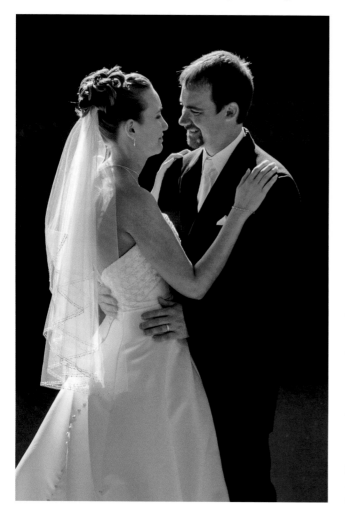

reflector—quite different from the boat-in-the-sunrise photo.

In this photo, I wanted the couple to be properly exposed. Because they were standing in direct light, I had to close down my aperture, thus rendering the background very dark. I chose this background for a specific reason: to enhance the effect of the backlighting. Imagine a light background such as a skyline. That type of background would have destroyed our rim light effect.

Cropping

Cropping in-camera is yet another way to create an artful composition. Cropping into an object can force the viewer to mentally fill in the blanks. This will, in turn, force the viewer to be actively engaged in studying your image.

Cropping an object in a photo will diminish the importance of that object. In other words, cropped objects that may play a part in the composition will not come across as the main subject. When zooming in to your subject, you are choosing what to keep and what to leave out.

For example, **image 6.12** shows the groom kissing the hand of his new bride. Because the bride's eyes are not visible in the frame, the emphasis is on the groom. Notice that I used the rule of thirds to place the rings in the lower-right corner. Since the groom is looking at his wife, this tends to continue the counter-clockwise motion. After a quick glance at the bride, it is the contrast of the hands against the black jacket that brings your eyes back to the rings.

Image 6.11. Sears wedding. Butler, PA. Canon EOS 30D with 28–135mm f/3.5–f/4.5 lens at 120mm. Exposure: ISO 400 at $^1/_{750}$ second and f/8.

Image **6.12** (top). Townsend wedding. Freeport, PA. Canon EOS 30D with 28–135mm f/3.5–f/4.5 lens at 100mm. Exposure: ISO 400 at $^1/_{90}$ second and f/11. Image **6.13** (center). White birch. Presque Isle State Park, Erie, PA. Canon EOS 7D with 28–135mm f/3.5–f/4.5 lens at 135mm. Exposure: ISO 100 at 0.7 second and f/22. Tripod-mounted camera. Image **6.14** (bottom). Engine. Apollo, PA. Canon EOS 30D with 28–135mm f/3.5–f/4.5 lens at 75mm. Exposure: ISO 100 at $^1/_{90}$ second and f/11.

Image 6.13 is an example of a crop to isolate a nondescript subject. I placed the reddish-black knot in the lower-left corner of the frame, per the rule of thirds. Broken down, the knot is a black circle on a light-gray background.

The small black flecks in the bark create the opportunity to investigate the image beyond the subject. A close look reveals the pastel colors that make up the bark on the white birch tree. Without the texture and pastel colors, we would have the "text" look—in other words, a black circle against a solid, even, unbroken light-gray background.

This image covers an area of 4x6 inches. Taking the time to study tiny bits of nature may produce a very complex image. Subjects like these are often overlooked by the typical passerby.

In **image 6.14**, the red grabs your attention. The crisp reflections of the chrome keep your gaze moving throughout the image. The reflections are made from the clouds and deep shadows of the bike itself. The reflections of the white clouds against the black shadows created many hard edges that helped create the mechanical look I wanted.

Imagine this bike inside a dark-colored garage. The emphasis here is on dark color,

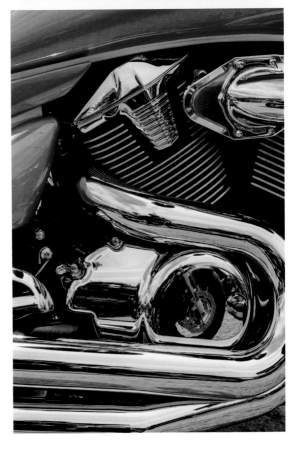

Image 6.15 (top). Maple leaf. Acadia Park Loop Road, ME. Canon EOS 7D and 28–135mm f/3.5–f/4.5 at 105mm. Exposure: ISO 800 at ¹/₃₂₀ second and f/5.6. Image 6.16 (bottom). Lighthouse. Portland, ME. Canon EOS 7D with 28–135mm f/3.5–f/4.5 lens at 135mm. Exposure: ISO 400 at ¹/₁₀₀ second and f/5.6. Tripod-mounted camera.

not necessarily dark lighting. Since the chrome reflects what is around it, that image would have been entirely different. In the garage photo, you would end up with far more losts than founds on the chrome. In the imagined photo, I will maintain my red, but with very little contrast in the chrome. With that result, the red would have been overpowering.

Note the front wheel of a bike next to this one in the lower-right corner. In photos such as this, it is a challenge to keep your own reflection out of the image.

Natural Filters

In general, a filter is used to manipulate the final look of the image. With dozens of options to choose from, it can get overwhelming. There are many that help, yet some may actually hurt an image.

To continue exercising our imagination and creativity, we will look at some naturally filtered images. In **image 6.15** and **image 6.16**, water is used in two different ways to distort the images. The maple leaf is actually underwater. It is the surface reflections of the water that distort the

shape below. The lighthouse is a reflection on the subtle movement of the water.

Image 6.17 was photographed through a window covered with raindrops. I used a shallow depth of field to blur the bridge in order to place more emphasis on the water droplets. In this shot, the camera was only about 18 inches from the window.

In **image 6.18,** I was outside looking through the window. The couple is actually looking at what is being reflected in the window. The reflection is superimposed over the couple, so the image now takes on a "double exposure" look. This gives the hint of the outside scenery.

Although a polarizing filter can be used to eliminate reflections, there may be a time when you want the reflection.

Image 6.17 (top). The 16th Street Bridge. Pittsburgh, PA. Canon EOS 30D and 28–135mm f/3.5–f/4.5 lens at 65mm. Exposure: ISO 400 at ¹/₁₂₅ second and f/8. **Image 6.18** (bottom). Marino wedding. Pittsburgh, PA. Canon EOS 30D with 28–135mm f/3.5–f/4.5 and 28mm. Exposure: ISO 400 at ¹/₉₀ second and f/11.

Patterns

For our purposes, the term "pattern" will be used to describe what is going on within the defined shapes in our image. As we look at this aspect of composition, then, we will be taking the "alike shapes" and "breaking alike shapes" compositional rules one step further. With those elements, it was the perimeters of the shapes that were the eye-catching elements. Now we are interested in the shapes' interiors.

In **image 6.19** and **image 6.20**, there are distinct shapes involved; however, the patterns within the shapes demand a closer look.

In the first image, the washed-out grass along the edge of Cherry Run creates a strong linear pattern. The strong contrast of the light and dark shapes first grabs your attention, but it lacks the ability to hold it. Enter the intricate and repeating patterns of the grass. Now your eye is given an opportunity to bounce from one clump to another.

In our second example (**image 6.20**), the circular shape of each individual flower draws the eye. Again, it is the repeating pattern of the inner flower that creates a flow. Just like the human eye reacts to color and shapes, it will relate

Image **6.19** (left). Grass. Cherry Run, Burrell Township, PA. Canon EOS 10D with 28–135mm f/3.5–f/4.5 lens 50mm. Exposure: ISO 400 at $^1/_{500}$ second and f/5.6. **Image 6.20** (bottom). Roses. Pittsburgh, PA. Canon EOS 30D with 28–135mm f/3.5–f/4.5 lens at 90mm. Exposure: ISO 800 at $^1/_{90}$ second and f/8. Ambient light only.

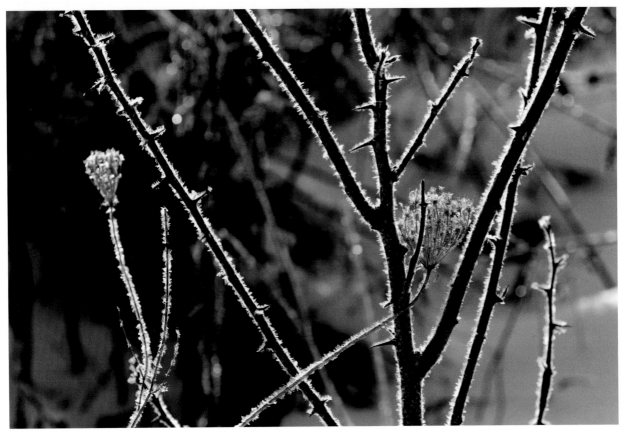

Image 6.21. Frost. Parks Township, PA. Canon EOS 7D with 28–135mm f/3.5–f/4.5 lens at 135mm. Exposure: ISO 400 at ¹/₅₀₀ second and f/11.

to a repeating pattern, which can tie different shapes and colors together.

Imagine that I had a triangle, circle, and a square with a different colored brick wall pattern in each one. Because the shapes and colors would be dissimilar, the viewer's eyes would likely be drawn to the brick pattern—the unifying element of the composition. It is the bricks that would most likely hold the viewer's attention.

In **image 6.21,** the pattern outlines and defines the shapes. There are other elements and effects of composition that support the pattern. The backlighting effect portrays the frost as a strong, white, even contrast. Since the even contrast lacks losts and founds, it tends to jump

out at you. In other words, it has the sort of impact that text might have on an image.

Abstracts

"Abstract art" is a loose term used to refer to a work that is partially or completely abstract. For our purposes, we will refer to an abstract as "a break away from reality," either partial or complete depending on how far from reality the subject is rendered.

For example, if we had a loosely outlined solid red octagon with a white horizontal line in it, what could it be? Some would recognize it as an American stop sign. This would be the group of drivers in America who are familiar with that particular shape. In other words, the STOP sign

Image 6.22 (top). Barnacles. Pemequid Point, ME. Canon EOS 7D with 28–135mm f/3.5–f/4.5 lens at XXmm. Exposure: ISO 400 at $^1/_{250}$ second at f/8. **Image 6.23** (bottom left). Autumn. Burrell Township, PA. Canon EOS 30D with 28–135mm f/3.5–f/4.5 lens at 135mm. Exposure: ISO 400 at $^1/_{125}$ second and f/5.6. **Image 6.24** (bottom right). Frozen. Burrell Township, PA. Canon EOS 10D and 28–135mm f/3.5–f/4.5 lens at 120mm. Exposure: ISO 400 and $^1/_{500}$ second at f/8.

as an abstract form would be recognizable to only those who have experienced it. Others may see the dynamic shape and bold color but not know what it represents.

That is the challenge of the abstract form. With nothing to refer back to—no reference point—viewers may be confused about what they are looking at.

The following photos are samples of subjects as partial or complete abstracts. The partial abstracts may be considered recognizable, with a surreal twist.

Image 6.22, which I've titled *Barnacles,* is an example of a pure abstract form. Obviously, as the image name implies, the subject is barnacles. The subtle wave pattern on the shallow water is enough to distort the obvious. How different would this piece be with a name like *Colors?* An image name can be very suggestive.

Image 6.23 reveals no clue as to what it really is. It first appears as some type of sand pattern or even a magnified view of a moth wing. The actual size of the object is about 6x9 inches. What is it? It is the inner side of sycamore bark, which this tree sheds annually, making it an excellent opportunity for abstract close-ups. With this type of subject matter, cropping will produce endless variations. Again, the challenge is to hold the viewer's attention.

Image 6.24 offers a somewhat recognizable subject against a surreal background. The maple branch is hanging

down into a stream. When the water rises, leaves flow down the stream and get tangled on the branch, creating an unusual pattern. Because this image was taken in early winter, the water presents as an opaque gray background. The small patch of open water reflects the trees on the opposite side of the stream. Cropping in on your subject eliminates the mundane surroundings and may leave you with a successful abstract.

Detail

We will refer to detail as a compositional effect because it depends on our depth of field.

When painting, an artist can choose the areas of the art work that will show detail; as photographers, we cannot achieve the same goal, no matter our camera or lens. We must rely on depth of field to control the amount of detail that is visible and, more importantly, where we will place it.

In **image 6.25**, we can see edge-to-edge detail. This is due to a shallow picture box. In other words, everything in the photo is on the same plane. This type of detail will create many found edges due to the color contrast. It gives

Image 6.25. Barnacle shells. Pemequid Point, ME. Canon EOS 7D and 28–135mm f/3.5–f/4.5 lens at 115mm. Exposure: ISO 100 at $^{1}/_{125}$ second and f/5.6.

the viewer many opportunities to study each and every shell. We can look at this as a textbook image in which everything is in focus for reference and accuracy.

Image 6.26 is another textbook photo, but everything is not on the same plane. Note the gravel in the background in the upper-left corner. Because the bike is perpendicular to the camera it will remain in sharp focus. In this photo, my eye tends to go to the engine since it is a light object against dark surroundings. The opposite occured in image 6.25; the large, dark shell against a light background grabs my attention.

By having everything in focus, other elements and effects will play an important part in defining the subject. When not used properly, an overabundance of detail may confuse the viewer as to what he or she should be observing.

In the painting world, an ultra-detailed background will lose its depth, as everything will appear to be in the same plane. Artists will use other elements of composition to define their subject. In photography, we have the ability to use a lens with greater focal power. This will dramatically reduce the depth of field. When we focus on our subject, it will remain sharp. By diffusing everything else in the image, our subject will be defined by sharpness alone.

The photo of the cardinals, image 6.27, is a telephoto sample we can call "detail versus red." The cardinal pair is foraging for food on a mid-winter day. Working from a blind, I was only about 8 feet away from these cardinals. I caught the female's attention while firing off a sequence of photos.

In this photo, the female is in sharp focus and grabs my attention first. I then move on to the gob of red that is the male. After a quick glance at the male, I return to the texture and detail apparent in the grass and on the female. Some may see the male first, the bright

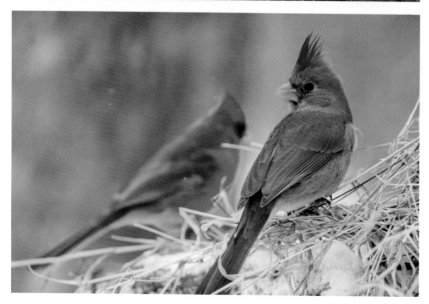

Image 6.26 (top). Custom bike. Apollo, PA. Canon EOS 30D with 28–135mm f/3.5–f/4.5 lens at 50mm. Exposure: ISO 400 at $^1/_{350}$ second and f/8. Image 6.27 (bottom). Cardinals. Vandergrift, PA. Canon EOS 7D with a 1.4x converter and EF 70–200mm f/2.8L USM lens. Focal length: 217mm. Exposure: ISO 800 at $^1/_{800}$ second and f/4.

Image 6.28 (left). Cadillac Mountain. Acadia National Park, ME. Canon EOS 7D with EF 14mm f/2.8L USM lens. Exposure: ISO 100 at ⅛ second and f/16. Tripod-mounted camera. Image 6.29 (right). Cody at Black Water Falls State Park, WV. Canon EOS 30D with 28–135mm f/3.5–f/4.5 lens at 70mm. Exposure: ISO 400 at 1/180 second and f/6.7.

red is an eye grabber. If the move is then to the female, my composition is safe. Why?

When creating an interesting composition, it should be a never-ending journey. The viewers may jump onto the path anywhere they like. However, it will be the scenery along the way that keeps them there. In other words, it will be your job to plan the elements and effects of the composition to hold their attention.

In this photo, I strove to create a subtle interaction between the two birds at feeding time. If my goal was to portray a female cardinal as the only subject, the bold red male would have to go.

Perspective

Photographers use perspective as a more interesting way to view the subject. If you ever heard someone say "Wow, look at that!" they may be referring to a typical subject viewed in an entirely different way. Most folks go through life looking down on some objects and up at others. When you change their angle of view, a whole new world springs into view.

The subject in **image 6.28** is a typical rock, not more than a foot tall. At Acadia National Park, this rock is probably walked over hundreds of times a day. I doubt if very many people have the time to view it from this perspective. Getting down to the level of the granite shows colors and patterns beyond belief. Note the light blue and yellow-green fungus. They tie directly into the colors of the vegetation and sky—a natural occurrence that cannot be improved.

I am able to get close to the fungus and place more emphasis on its colors by shooting from a low perspective. This photo was taken with an ultrawide-angle (14mm) lens. The lens gave me the depth of field I was looking for to maintain my color and texture.

In **image 6.29**, the subject was standing at the bottom of a 15-foot overhang. Standing directly over him, I shot this photo.

There are several advantages to shooting from this perspective or angle. For one, if needed, you will limit what is in your background.

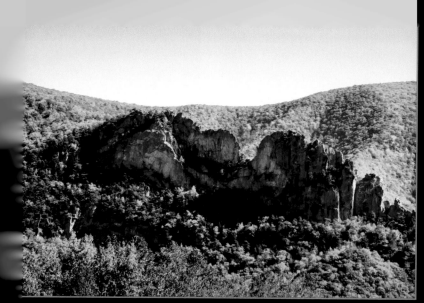

Image 6.30. Entrance. Seneca Rock State Park, WV. Canon EOS 30D with 28–135mm f/3.5–f/4.5 lens at 112mm. Exposure: ISO 400 and $1/250$ second at f/11.

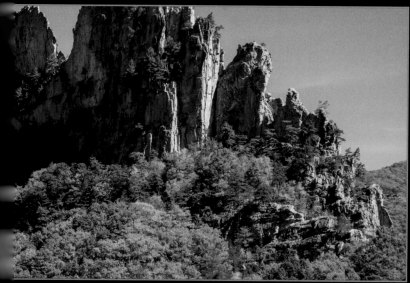

Image 6.31. At the base. Seneca Rock State Park, WV. Canon EOS 30D with 28–135mm f/3.5–f/4.5 lens at 127mm. Exposure: ISO 400 at $1/500$ second and f/11.

Image 6.32. At the top. Seneca Rock State Park, WV. Arca Swiss F-1 with Schneider 90XL f/5.6 lens and Horseman 6x12cm film back. Provia RDP II 100 at $1/8$ second and f/11. Tripod-mounted camera.

The area shown in this photo is just 24 square feet. Also, in a full-length photo such as this, the person's face will be proportionally larger, which is more suitable for wallet-sized photos.

When photographing female subjects, I often shoot from a slight downward angle. Why? Their boyfriends/husbands are usually taller than they are, so the angle of view is familiar to them. In other words, my aim was to capture the image from a man's perspective.

The next three photos show Seneca Rock, West Virginia, from varying perspectives. I shot **image 6.30** from the road coming into the park area. With a small zoom, I was able to crop in on just the rock formation. At eye level, the rock wall does not appear that dramatic. The mountain in the background does not help. It creates an unflattering comparison.

The second Seneca Rock photograph (**image 6.31**) was taken from an open field just below the wall. This perspective changed everything. The mountain in the background now appears to be lower than the wall. With this same lighting, the jagged rocks are much more pronounced and more inviting to the would-be rock climber. I photographed this same shot later in the day on the way home. It was okay, but with the light directly behind me the photo was flattened and the jagged-rock look was lost. *Note:* I intentionally cropped the very top off to keep the actual altitude a mystery.

The third shot in the series (**image 6.32**) is a hint of what the typical hiker can expect from the top. The trail to the top takes about 45 minutes to walk. The rock wall shown in this photo is only about 20 feet wide, with an impressive drop-off on either side. In the upper-right corner, Spruce Knob, the highest mountain in West Virginia, is pictured faintly.

Tension

Tension is defined as the close proximity of two objects creating action and a focal point in your photo. In **image 6.33**, the house finch is leaning over to grab a bite of the rose hip. The chunk still in its beak makes this a "real time" photo.

This type of interaction may present itself as the subject, whether it is or not. When trying to illustrate any given subject, tension in the background will prove to be a distraction, pulling too much attention away from the subject. Establishing a balance between your main subject and tension in the background can be a challenge.

Image 6.33. House finch photographed from a blind in Burrell Township, PA. Minolta 9xi with a 1.4x converter and 300mm APO f/2.8 lens. Exposure: Provia RDP II 100 at $^1/_{125}$ second and f/4. Tripod-mounted camera.

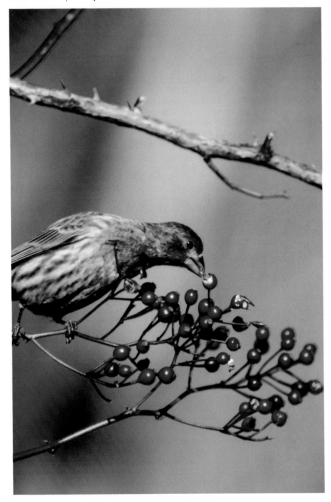

Image 6.34. Gulls at Bayfront in Erie, PA. Canon EOS 30D 28–135mm f/3.5–f/4.5 lens. Exposure: ISO 400 and ¹/₂₀₀₀ second at f/8.

Image 6.34 is an example of tension between two gulls. A brief encounter suggested that it was the mother bird, on the left, interacting with a juvenille.

To capture **image 6.35**, I used my ultra-wide-angle lens to focus on the driftwood resting on the beach. An ultrawide-angle lens is an excellent tool for placing the viewer in the photo. I shot this image just 12 to 18 inches from the foreground branch. This shoot would be very difficult without this type of lens.

When using an ultrawide-angle lens, moving as little as an inch in any direction will change your composition dramatically. Due to the late-evening sun, I was able to maximize my depth of field without using a tripod. This composition would not have been possible without an ultrawide-angle lens.

I was careful to frame the image with the branch pointing at the lighthouse. I felt this would add to the tension between the branch and the lighthouse. The branch in the upper-left corner received the same angle of light as the lighthouse and, consequently, presented the same contrast against the deep-blue sky.

Note how the bottom branch resting on the sand is toned down due to the color of the sand. The sharp detail of the bottom branch places it in the foreground nicely, but it is not as eye-catching as the top branch. Looking at

the top branch, it is very difficult not to glance at the lighthouse. I tried to place them close enough to almost interfere with each other in order to introduce the sense of tension I was looking for.

Image 6.35. Lighthouse in Presque Isle State Park, Erie, PA. Canon EOS 7D EF-S 10–22mm f/3.5-4.5 USM lens at 17mm. Exposure: ISO 100 at $1/125$ second and f/13.

Key Skills in This Chapter:

1. Improve your odds of success by capturing more.

2. Strive for variety in your images.

3. Enhancing your images in postproduction.

Image 7.1. Kayaker in Ohiopyle State Park, PA. Canon EOS 7D with a 1.4x converter and EF 70–200mm f/2.8L USM lens. Focal length: 238mm. Exposure: ISO 400 at $^1/_{6000}$ second and f/4.5.

I really enjoy photographing fast action. When the action is unfolding in the blink of an eye, as it was when I shot the photograph of the kayaker shown in **image 7.1**, I am not even sure what I have just captured. This will often lead to a pleasant surprise in the editing room. When things happen this quickly, it is good to have luck on your side. Fast shutter speeds and a lot of light will also help ensure your success.

Grab Every Opportunity

I only wish I had all of the photos that I didn't take!

In other words, don't miss obvious photo opportunities while looking for difficult ones. At the first sign of a good photo op, stop and capture an image—even if you are on your way to your final destination. (Be careful—keep your eyes on the road!) When I go on any of my photographic journeys, I actually start from my parked vehicle and work outward from there.

For example, **image 7.2** shows the fragile ice crystals on the perimeters of the leaves of a blackberry bush. While the field was in shadow, I took my chance! Even in October, the morning sun can melt the ice crystals quickly.

Image 7.2. Blackberry. Burrell Township, PA. Canon EOS 7D with EF 28–135mm f/3.5–5.6 IS USM lens at 65mm. Exposure: ISO 400 at $^1/_{45}$ second and f/11.

Image 7.3 (above). Mushroom in Brick Church, PA. Canon EOS 7D with EF 28–135mm f/3.5–f/5.6 IS USM lens at 38mm. Exposure: ISO 100 at $^1/_3$ second and f/19. Tripod-mounted camera. Image 7.4 (left). Snowy egret photographed in Assateague, MD. Canon EOS 7D with a 1.4x converter and EF 70–200mm f/2.8L USM lens. Focal length: 210mm. Exposure: ISO 200 at $^1/_{2000}$ second and f/4. Tripod-mounted camera.

As shown in **image 7.3**, some found subjects are small and could be easily missed. Keep in mind that each photo covers less than half of a square foot. However, both the blackberry leaves and mushroom were no more than 10 feet from the road.

I often have to slow myself down thinking that I am missing the "big photo op" ahead. For example, I was traveling back and forth between Chincoteague and Assateague when a flock of snowy egrets along the road caught my eye. A concentration of minnows at a spillway was keeping the birds occupied. I was able to get rather close to take **image 7.4**. Using an f/4 aperture eliminated the background. The out-of-focus background is the water reflecting the sky light. Chincoteague and Assateague hold many photo ops very close to the roads.

I sometimes seek out small subjects to photograph at the start of any photographic journey. When all else fails on my photo trips, I also end my journey by looking for macro (small) subjects. A small area is more easily controlled than a full-size landscape area. No matter what the reason for a lack of photo ops, searching for small subjects may be the answer. **Image 7.5** was taken while walking the shore of Lake Erie.

Don't Stop at One

With an extensive film background, I thought I'd never say "I love working with digital media." In April 2012, I took a trip to Chincoteague, Virginia. I was there for about three days and brought home 4,300+ digital images. Not too long ago, I would have had several hundred dollars invested in the film and developing.

Image 7.5. Snail shells. Presque Isle State Park, PA. Canon EOS 7D with EF 28–135mm f/3.5–f/5.6 IS USM lens. Exposure: ISO 100 at ¹/₅₀₀ second and f/5.6.

Since making the transition to digital, I experiment more than ever. My suggestion is, always take more than one photo of your subject—in fact, take many—but don't stop thinking about what you are photographing. Avoid the false sense of security in the numbers game. In other words, study what is going on within the frame of every image you capture. Otherwise, you may end up with thirty photographs with the same distracting object in the background.

Photographing your subject several different ways will also sharpen your thought processes and creativity. In action photography, multiple photos are a must. You will need sharp reflexes and a good understanding of your subject in order to record fast action. With practice, you will be able to rely on skill more than luck.

What is the difference between skill and luck? I may owe it to a sports background to look for patterns and habits in movement. This is a skill. For example, when I was trying to photograph my great blue heron series (**images 7.7** through **7.12**), I noticed that the bird would wade or stand for several minutes before striking. However, after watching for a while, I realized that the heron would give me a hint when it was going to strike—it would drop just a bit for a split second before launching at the minnow, giving me the head start I needed to react. Once I saw the bird focusing downward, I knew to get ready. When I saw the bird dip, it was showtime. For these six photos, I was relying on skill and experience more than luck.

What is luck? **Image 7.6** was a lucky shot. I never would have anticipated the minnow breaking free of the bird's grip. I was ready for the great egret photo, and with luck the minnow was a nice addition to this image. Generally speaking, I always welcome luck!

Image 7.6. Great egret. Assateague, MD. Canon EOS 7D with a 1.4x converter and EF 70–200mm f/2.8L USM lens. Focal length 280mm. Exposure: ISO 400 at $^1/_{500}$ second and f/6.7.

s 7.7 through 7.12. Great blue heron. Assateague, MD. Canon EOS 7D with a 1.4x converter and EF 70-200mm f/2.8L USM lens. ength 280mm. *Images 7.7 through 7.10:* Exposure: ISO 1000 at ¹/₁₀₀₀ second and f/4. *Images 7.11 and 7.12:* Exposure: ISO 1000 at cond and f/4 (aperture-priority mode). Tripod-mounted camera. Note that all six photos were captured in 2 seconds.

e 7.7. Image 7.8. Image 7.9.

The Road to Success Includes Variety

The photos in this chapter represent accessible opportunities for those who look. The subjects you choose are up to you. Scenes along the road often make a nice backdrop for family photos. Many of the people photos in this book were shot on location at several state parks. This makes it easy for the model. Water, rocks, trees, and buildings can be used in endless combinations depending on the angle of view.

Image 7.13 depicts a classic barn in heavy snowfall. What sets this barn apart are the louvered windows. They are hard to find these days.

Image 7.14 shows a Canada goose gliding along in the early-morning sun. The finely detailed squiggle lines of the cattail reflections gave this image a painterly look, and the clear-blue sky gave the water an airbrush effect. This photo was taken near the Presque Isle State Park office. I chose an angle of view that would eliminate the office building and keep my solitary bird theme alive.

Image 7.15 is a monochromatic photo of a piece of knurled driftwood leaning against a sheet of weathered wood. This photo was taken at a roadside antique shop, where the photo ops were endless. Again, angle of view is important.

Image 7.15. Knurled wood. South West Harbor, ME. Canon EOS 7D with EF 70–200mm f/2.8L USM lens at 165mm. Exposure: ISO 100 at ¼ second and f/18. Tripod-mounted camera.

One positive thing to remember is that the road to success will begin in your own neighborhood. In other words, you will not need to travel the world to find photo opportunities. When you flex your creativity, the end result will be up to you.

The two sunset photos were taken within a half-hour's drive from each other. The first photo (**image 7.16**) was taken at Curtis Merritt Harbor in Chincoteague, VA. I used the sun as my primary subject and the silhouette of the fishing vessel as my secondary subject. With few clouds in the sunset sky, the color was limited to the horizon. The small zoom lens worked well to isolate the stark silhouette of the troller against the orange sky. Once the sun went down, I thought I was done for the day.

Driving up Main Street going back to the motel where I was staying, I saw the sunset scene in **image 7.17**—the orange glow on the horizon was blending into the dark sky. This was an ultrawide-angle shot, placing more emphasis on the twilight. I wanted to portray the perfect sky gradation. Very seldom will you witness a sky with no distractions such as a jet condensation trail. Note the unbroken horizon line. I feel the strong silhouette of the dock is the counterbalance for the dark sky and provides the contrast necessary to break a path through the horizon line.

I was less than 20 feet from my truck when I captured these photographs. Subject choice and lens selection makes each photo different. If you have a sunset in mind, look for interesting objects to place with it.

Image 7.16 (above). Sunset. Chincoteague, VA. Canon EOS 7D with EF 28–135mm f/3.5–f/5.6 IS USM lens at 80mm. Exposure: ISO 400 at $1/125$ second and f/9.5. Tripod-mounted camera. **Image 7.17** (facing page). Sunset. Chincoteague, VA. Canon EOS 7D with EF-S 10–22mm f/3.5–f/4.5 USM lens at 18mm. Exposure: ISO 100 at $1/2$ second and f/4.5. Tripod-mounted camera.

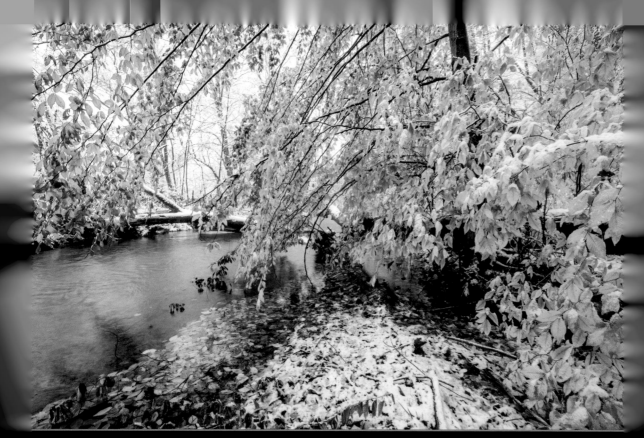

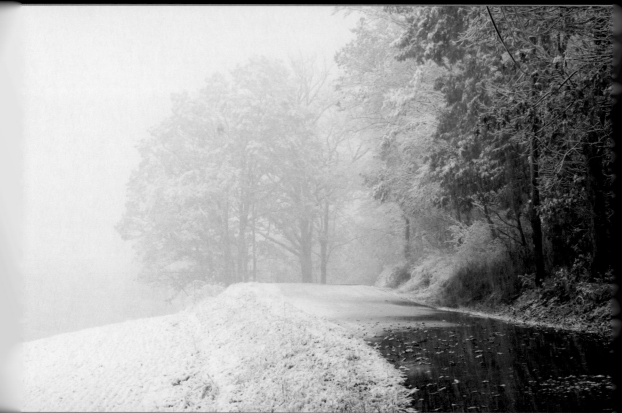

mage 7.18 (top). Fall color. Burrell Township, PA. Canon EOS 7D with EF-S 10–22mm f/3.5–f/4.5 USM lens at 10mm. Exposure: ISO 400 at ¹⁄₂₅₀ second and f/5.6. Tripod-mounted camera. **Image 7.19** (bottom). Ridge Road. Vandergrift, PA. Canon EOS 7D with EF 28–135mm f/3.5–f/5.6 IS USM lens at 65mm. Exposure: ISO 400 at ¹⁄₃₀ second and f/11. Tripod-mounted camera.

The next two images are examples of maximizing variety, and both were less than 30 yards from my truck. Again, subject choice and distance will make the difference. These snow photos were taken on the same day during an all-day snow.

Image 7.18 shows the vibrant colors of beech trees. Placing the camera less than 15 feet from the first tree eliminated the atmospheric effect the snow would have from a distance, thus keeping the bright colors vibrant. Note that the tree trunks just beyond the creek are toned down by the snowfall.

Image 7.19 consists of all oak trees, which are usually brown in the fall. This scene offered no vibrant color to work with, so I opted to show-case the atmospheric effect created by the heavy snowfall. The trees in this scene were more than 100 yards away. The loss of visibility reduced the trees to ghostly silhouettes. When working with what you are given, emphasize the obvious. Your end result will be stronger photos—and more of them.

Composition to Consider

For **image 7.20**, I wanted to break the horizon line on the right. I decided that incorporating an image of a gull would introduce a white tone to counterbalance the waves. I used this particular bird photo since it was shot with the same lighting angle as the landscape image. Note that I had to re-create the bird's right wing tip.

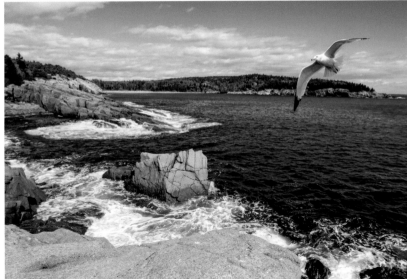

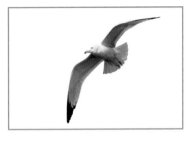

Image 7.20 (top left). Monument Cove. Acadia National Park, ME. Canon EOS 7D with EF 14mm f/2.8L USM lens. Exposure: ISO 100 at $^1\!/_{250}$ second and f/11. **Image 7.21** (center left). Gull at bayfront. Erie, PA. Canon EOS 30D with EF 28–135mm f/3.5–f/5.6 IS USM lens at 135mm. Exposure: ISO 400 at $^1\!/_{2000}$ second and f/6.7. **Image 7.22** (bottom left). Gull with wingtip retouched. **Image 7.23** (above). After digital retouching.

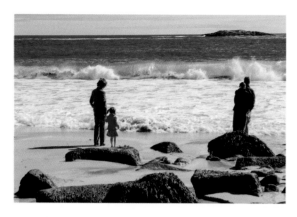

Image 7.24 (left). My daughter at Sand Beach. Original image. Acadia National Park, ME. Canon EOS 7D EF 28–135mm f/3.5–f/5.6 IS USM with 53mm. Exposure: ISO 400 at $^1/_{500}$ second and f/16. Image 7.25 (below). Here is the image after retouching was done.

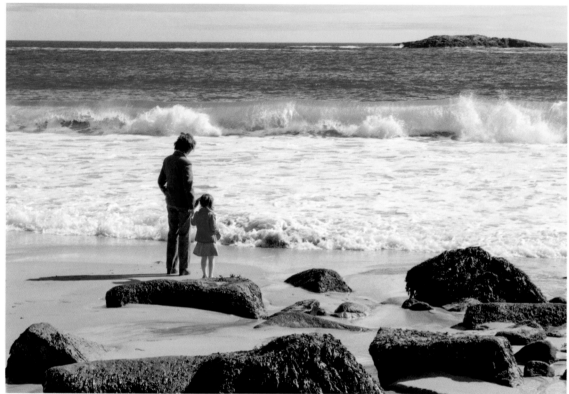

In **image 7.24**, there are two sets of competing subjects. I liked the mom and daughter in the lower left more than the other couple. Why? The couple on the right were standing in line with the camera. They appear close in size with the same color values, making them look like one person at a quick glance.

The mother and daughter are standing at an angle to the camera; this helps to make them seem more interesting. They wore different colors, and there is a size difference between the two. In this photo, you can see the difference between the two couples and how they would compare to create a specific mood.

When I take candids of people, I capture authentic moments. I do not rearrange the subjects or ask them to move. Both couples came into my photo and left together, so I had

no choice but to photograph them both. I tried to recompose my image with the mother and daughter in the lower right-hand corner, but it did not work. They were too close to the right side of the photo and looking out to the right. Their eye direction would have made viewers question what they were looking at—and I wanted the viewer to see what the subjects were seeing.

In **image 7.26**, the water seems to drain out of the photo, taking your eye with it. In **image 7.27**, the retouched photo, I digitally created ice in the lower-left corner. This blocked my lower-left corner. (Review Blocking Corners on pages 65–66.) With the dark water confined, I created the vignette effect I was looking for. In the retouched photo, the leaves in the lower right and the edge of the new ice establish a reoccuring starting point in the foreground.

These retouched photos are presented to show how a subtle adjustment can change the dynamics of your composition. In my own photography, I keep the images as true as possible. Whether it be true to life or artificially adjusted, the end result will always be your compositional decision.

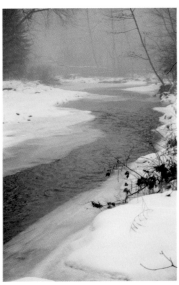

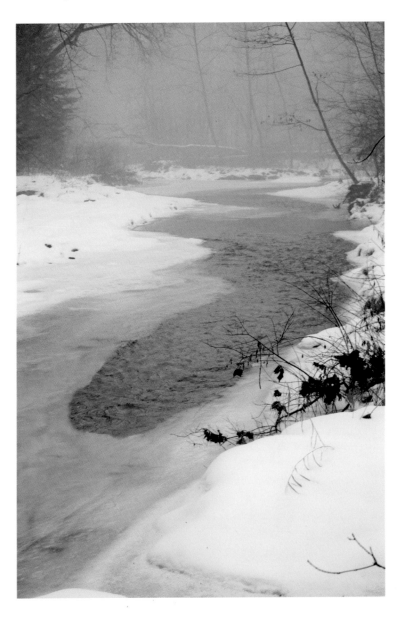

Image 7.26 (above). Cherry Run, before retouching. Burrell Township, PA. Canon EOS 10D with EF 28–135mm f/3.5–f/5.6 IS USM lens at 47mm. Exposure: ISO 400 at $^1/_{350}$ second and f/5.6. **Image 7.27** (right). The retouched, final image.

Image 8.1 (above). Scott Fitzpatrick. Assateague Seashore, VA. Canon EOS 7D with a 1.4x converter and EF 70–200mm f/2.8L USM lens. Focal length: 280mm. Exposure: ISO 200 and $\frac{1}{2000}$ second at f/4. **Image 8.2** (facing page). Sunset. Assateague National Seashore, VA. Canon EOS 7D with EF-S 10–22mm f/3.5–f/4.5 USM lens at 22mm. Exposure: ISO 100 at $\frac{1}{60}$ second and f/4.5. Tripod-mounted camera.

Final Thoughts

I enjoy traveling to new and wonderful places. Each destination offers its own subject matter and conditions. I often return to a chosen location at varying times of the year. With every trip, I add thousands of new images to my collection.

Over the years, I have learned that patience is worth its weight in gold. Taking the time for a short conversation with the local folks often reveals valuable insight on what to do and where to go. By reaching out, I have met some interesting people and made new friends. In many cases, I've found that I've made a trustworthy contact for my next trip.

In outdoor photography, there are so many variables at play that no two situations are ever identical. The angle of light, color, subject matter, weather conditions, and equipment selection combined yield different results. To master photography is to master the conditions. Only when you've mastered the conditions will you know the full extent of your creative abilities.

When I look back on my early photos, I can remember a little tidbit about each one. I truly believe a photographic memory can be developed over time. This is a part of mastering your conditions. Experience and patience take time to learn.

Whatever level you plan to take your photography, I hope this book has helped you on your way. Remember, to master composition is to understand the way people think.

May your photographic journey be a colorful one.

In loving memory of Nicholas A. Gallovich.

Index

Step-by-Step Wedding Photography, *2nd ed.*

Damon Tucci offers succinct lessons on great lighting and posing and presents strategies for more efficient and artful shoots. *$27.95 list, 7.5x10, 128p, 225 color images, order no. 2027.*

Shoot Macro

Stan Sholik teaches you how to use specialized equipment to show tiny subjects to best effect. Includes tips for managing lighting challenges, using filters, and more. *$27.95 list, 7.5x10, 128p, 180 color images, order no. 2028.*

Portrait Pro

Veteran photographer Jeff Smith shares what it takes to start up and run an effective, profitable, and rewarding professional portrait business. *$27.95 list, 7.5x10, 128p, 180 color images, order no. 2029.*

Photographing Newborns

Mimika Cooney teaches you how to establish a boutique newborn photography studio, reach clients, and deliver top-notch service that keeps clients coming back. *$27.95 list, 7.5x10, 128p, 180 color images, order no. 2030.*

Photograph Couples

Study images from 60 beautiful wedding and engagement sessions. Tiffany Wayne shows what it takes to create emotionally charged images couples love. *$27.95 list, 7.5x10, 128p, 180 color images, order no. 2031.*

The Art of Engagement Portraits

Go beyond mere portraiture to design works of art for your engagement clients with these techniques from Neal Urban. *$27.95 list, 7.5x10, 128p, 200 color images, order no. 2041.*

Essential Elements of Portrait Photography

Bill Israelson shows you how to make the most of every portrait opportunity, with any subject, on location or in the studio. *$27.95 list, 7.5x10, 128p, 285 color images, order no. 2033.*

Boudoir Lighting

Robin Owen teaches you to create sensual images that sizzle with evocative lighting strategies that will amplify your subject's assets and boost her confidence. *$27.95 list, 7.5x10, 128p, 180 color images, order no. 2034.*

How to Photograph Weddings

Twenty-five industry leaders take you behind the scenes to learn the lighting, posing, design, and business techniques that have made them so successful. *$27.95 list, 7.5x10, 128p, 240 color images, order no. 2035.*

Tiny Worlds

Create exquisitely beautiful macro photography images that burst with color and detail. Charles Needle's approach will open new doors for creative exploration. *$27.95 list, 7.5x10, 128p, 200 color images, order no. 2045.*

Fine Art Portrait Photography

Nylora Bruleigh shows you how to create an array of looks—from vintage charm to fairytale magic—that satisfy the client's need for self-expression and pique viewers' interests. *$27.95 list, 7.5x10, 128p, 180 images, order no. 2037.*

The Right Light

Working with couples, families, and kids, Krista Smith shows how using natural light can bring out the best in every subject—and result in highly marketable images. *$27.95 list, 7.5x10, 128p, 250 color images, order no. 2018.*

Dream Weddings

Celebrated wedding photographer Neal Urban shows you how to capture more powerful and dramatic images at every phase of the wedding photography process. *$27.95 list, 7.5x10, 128p, 190 color images, order no. 1996.*

The Big Book of Glamour

Richard Young provides 200 tips designed to improve your relationship with models, enhance your creativity, overcome obstacles, and help you ace every session. *$27.95 list, 7.5x10, 128p, 200 color images, order no. 2044.*

Light a Model

Billy Pegram shows you how to create edgy looks with lighting, helping you to create images of models (or other photo subjects) with a high-impact editorial style. *$27.95 list, 7.5x10, 128p, 190 color images, order no. 2016.*

The Beckstead Wedding

Industry fave David Beckstead provides stunning images and targeted tips to show you how to create images that move clients and viewers. *$27.95 list, 7.5x10, 128p, 200 color images, order no. 2045.*

Lighting and Design for Portrait Photography

Neil van Niekerk shares techniques for maximizing lighting, composition, and overall image designing in-studio and on location. *$27.95 list, 7.5x10, 128p, 200 color images, order no. 2038.*

Portrait Mastery in Black & White

Tim Kelly's evocative portraits are a hit with clients and photographers alike. Emulate his classic style with the tips in this book. *$27.95 list, 7.5x10, 128p, 200 images, order no. 2046.*

The Mo⋯

Robert Fi⋯ use a mo⋯ apps to c⋯ then forr⋯ maximi⋯ *128p, 2⋯*

Altern⋯

Benny M⋯ lighting⋯ to-the-p⋯ to creat⋯ *7.5x10,⋯ no. 204⋯*

The Sp⋯

Can you⋯ all of yc⋯ with inv⋯ Michael⋯ a resou⋯ *128p, 2⋯*

⋯OOKS AVAILABLE

⋯t Media®

⋯OX 586
⋯Y 14226 USA

⋯ purchase books from an⋯ To order directly, visit our⋯ ree number listed below to⋯ r credit cards are accepted. ⋯lleges: Write, call, or fax to⋯ formation, contact Amherst⋯ ia sales representative. Net⋯

⋯or (716) 874-4450
⋯) 874-4508

⋯dates, and specifications⋯ ange without notice. ⋯Payment in U.S. funds only.

⋯STMEDIA.COM
⋯KS AND ADDITIONAL INFORMATION